C000133169

complete guide for models
inside advice from industry pros

eric bean and jenni bidner

LARK BOOKS

A Division of Sterling Publishing Co., Inc.
New York

Book Design: Sandy Knight
Cover Designer: Barbara Zaretsky
All photographs by Eric Bean, except as noted below.
Jen Bidner's portrait on page 4 is © Meleda Wegner.
The model comp cards on pages 92 and 155 are courtesy of
Code Management.

Cover Model: Jodi Kelly

Editorial Assistance: Delores Gosnell

Library of Congress Cataloging-in-Publication Data

Bean, Eric.
 Complete guide for models : inside advice from industry pros /
by Eric Bean and Jenni Bidner.-- 1st ed.
 p. cm.
 Includes index.
 ISBN 1-57990-576-5 (pbk.)
 1. Models (Persons)--Vocational guidance. I. Bidner, Jenni. II.
Title.
HD8039.M77B43 2004
746.9'2'023--dc22
 2004001508

10 9 8 7 6 5 4 3 2 1
First Edition

Published by Lark Books, a division of
Sterling Publishing Co., Inc.
387 Park Avenue South, New York, NY 10016

Distributed in Canada by Sterling Publishing,
c/o Canadian Manda Group, One Atlantic Ave., Suite 105
Toronto, Ontario, Canada M6K 3E7

Distributed in the U.K. by Guild of Master Craftsman
Publications Ltd., Castle Place,
166 High Street, Lewes, East Sussex, England BN7 1XU
Tel: (+ 44) 1273 477374, Fax: (+ 44) 1273 478606
Email: pubs@thegmcgroup.com, Web:
www.gmcpublications.com

Distributed in Australia by Capricorn Link (Australia) Pty Ltd.,
P.O. Box 704, Windsor, NSW 2756 Australia

If you have questions or comments about this book,
please contact:
Lark Books
67 Broadway
Asheville, NC 28801
(828) 253-0467

Manufactured in China
ISBN: 1-57990-576-5

contents

about the authors

ERIC BEAN is a fashion photographer who is based out of New York City. Eric started his career in photography 15 years ago, shooting for every major modeling agency in New York City. He continues to work with these agencies on prestigious worldwide advertising campaigns.

Eric has worked for such distinguished clients as Harry Winston Jewelers, Salvatore Ferragamo, Avon Products, and W Hotels. He continues to deliver compelling images through his mastery of light and composition for large fashion companies and cutting edge designers. His online portfolio can be viewed at www.EricBean.com.

JENNI (JEN) BIDNER has 20 years experience in the photo industry as an editor, author, internet content manager, public relations professional, and photographer. She is the author of over a dozen books including *Dog Heroes: Saving Lives & Protecting America, The Lighting Cookbook,* and *Making Family Websites.* She is the former editor of *Petersen's Photographic* and several other magazines. She is a frequent contributor to *Outdoor Photography* and *Rangefinder* magazines.

Jen is a volunteer K-9 Search & Rescue handler with ILL-WIS Search Dogs unit in the Chicago area. She and her dogs Yukon and Ajax work to help find the lost and missing.

to our readers

The intent of the authors is to give aspiring models (and parents of aspiring models) a realistic view of the business. While we want to encourage your dreams and aspirations, we also want to instill a sense of realism about the industry.

Not all aspects of modeling are fun and glamorous. It is hard work when you're in front of the camera. It's even harder when you're off-camera, working to market your image. Even when you're not working, you have to live a healthy lifestyle, in order to maintain your natural beauty.

Throughout the book we emphasize that good looks don't insure you a successful career. The fashion world is fickle, and the preferred "look" can change almost overnight. Potential clients may not choose you for very subjective reasons that you will never be able to pinpoint. And even extremely successful models are faced with exponentially more rejection than success.

That being said, there are many models who have wonderful, lucrative, and long careers. Could you be one of them? Possibly. But remember, many have tried and failed for each one who has succeeded.

For this reason, we have emphasized inexpensive *but proven* ways to test the waters. These methods, discussed fully in Chapters 4 and 5, will also help you avoid the cons and scams that have hovered around the outskirts of the legitimate modeling industry. We can't imagine anything worse than being taken advantage of because you have a dream. If you understand how the legitimate businesses work, you will be able to avoid those that are not.

In Chapter 2, we outline the difference between a full-time model who has an agent, and a freelance model who does it occasionally for added cash or just plain fun. We also discuss the different specialties, and the looks and requirements for each.

Chapter 3 discusses the traits you will need to become a model. You may be surprised that it's not all just about a pretty or handsome face.

Chapter 5 is designed to help you understand the mechanics of the industry, covering business matters that every model should know.

Chapter 6 will give you information on what it's like to be a model on a day-to-day basis. This will help you decide if you think it will be work that you enjoy, by giving you real life insights into everything from casting calls to photo shoots.

We hope you enjoy this book and find it useful in planning your career!

Eric Bean & Jen Bidner

the industry insiders

We would like to thank the following individuals for generously agreeing to be interviewed. The insider information they shared makes up a significant portion of the book's content.

A special thanks goes to all the models who appear in this book as well. A donation to the Breast Cancer Research Foundation has been made in honor of their participation in this project.

agents

KATIE FORD is the president of Ford Models (Worldwide). She has led Ford since 1995 when she took over from her parents, Jerry & Eileen. Her goal has been to continue Ford's position as an industry trend-setter. In addition to the New York City headquarters, Ford has offices in Chicago, Los Angeles, Miami, Scottsdale, Toronto, Paris, Sao Paolo, Rio de Janeiro and Buenos Aires. Divisions include Women, Men, Celebrity, Sports, Classic, Commercial Print, 12 plus, Fit, Children and Teen, as well as talent and music management.

DAVID GRILLI is the Senior Booker/Women's Division at Code Management in New York City. Previously, he has worked at the following agencies: MTM (Chicago, owned by Elite), New York Models (New York), Pauline's (New York), Wilhelmina (New York), and Arlene Wilson (Chicago).

David has managed such models as Marianne Molski, Beverly Peele, and Sunniva Stordal, as well as current top models. He has negotiated contracts and campaigns for the industry's top clients including: Revlon, DKNY, Clinique, Dove, Clairol, Pantene, Coach, Max Factor, Gap, Banana Republic, and others. David has had numerous television appearances as well, including The Maury Povich Show, America Tonight, Inside Edition, Fox News, MTV, and The Eyewitness News.

SAM is a booker in the Men's Division of Ford Models (New York), where he has worked for over a decade. He is one of the top male modeling scouts in the country, and is responsible for managing the careers of some of the top male models in the world.

bookers & casting

MAURICIO PADILHA is the co-owner of Mao Public Relations, which specializes in working with young, cutting-edge fashion designers to produce their fashion shows. He is casting director for over 30 runway shows a year.

DARRYL BRANTLEY has been involved with fashion magazines for the past 15 years, working a variety of jobs from model booking to fashion editorial

positions for *Mirabella*. He currently works at *Vanity Fair* magazine.

MICHAEL LANGE is the owner of Micon Worldwide, a photo production company. He does the castings for major fashion shows, including Perry Ellis, Calvin Klein, Ralph Lauren, Narciso Rodriguez, Target, and Vera Wang. He is a former agent with Ford Models.

BRIAN SIEDLECKI is a Talent Executive for the television show *Saturday Night Live*, where he has worked for the past eight years. Part of his job includes casting.

models

CARMEN DELL'ORIFICE has been a model for almost 60 years. Beginning at 14 years old in the 1940's, she has posed for most of the top photographers for the past 50 years. Now in her 70s, she is busy as ever, doing runway fashion shows and major advertising campaigns, including the popular television ads for Target stores.

AMIE HUBERTZ is a model with Code Management in New York. She is currently a much-in-demand redhead. Her clients have included Clinique, Revlon, Gap, and Espirit. She has appeared most major fashion magazines.

JODI KELLY has been a model for over a decade. Her clients have included Bagley Mishka, Donna Karen, and Prada. Additionally, she has taught modeling classes. Her son John Thompson has modeled in a national advertising campaign for Baby Gap. Jodi is one of Eric Bean's favorite models, and many of her images are in this book.

LINDSEY KRAFT is a model with Code Management in New York City. She has been very successful working the Teen Division markets, and is currently transitioning to acting, having already appeared on *Law & Order: Special Victims Unit*.

SEBASTIAN LACAUSE is a model, actor, dancer and singer. He has been a featured performer in major Broadway musicals, including a co-starring role in Rocky Horror Show, He also had a prominent part in the movie version of Chicago, and is currently working on other Hollywood projects.

NICOLE POTTER is a professional makeup artist and model. She is known for her versatility as a model and her upbeat personality. She appears in many of the photos in this book, including the special "One Model" section on pages 162-163.

TODD RIEGLER, ESQ. is a model represented by Ford Models, who specializes in Body modeling. He has appeared on the cover of *GQ* magazine (May 2002). He is also a lawyer.

makeup artist

CYRUS KOOHPAIMA is a makeup artist who provided us with invaluable insights into makeup, health, and the role of models. His credits include major corporations (Dell, Sprint, AT&T), major magazines (*Cosmo, Details, Elle, GQ, Harper's Bazaar, NY Times*), top fashion shows (Tommy Hillfinger, Donna Karen, Calvin Klein, Alexander McQueen, MTV, Stephen Sprouse, Versace), leading photographers (Walter Chin, Annie Liebowitz, Ellen Von Unworth), celebrities (Debby Harry, Lauren Hutton, Iggy Pop), music videos ("*Spice Up Your World*" with the Spice Girls, Boy George, Lauren Hill, Hole, Puff Daddy), and even theater.

Most of the photographs in this book feature Cyrus' makeup artistry. To see more of Cyrus' work, visit his website at www.cyrusk.com.

health professional

DANIEL LUCAS is a physical therapist, certified Optimum Performance Trainer through the National Academy of Sports Medicine. He is also certified through the National Strength Conditioning Association.

unnamed sources

We would also like to thank those industry experts who contributed valuable information, but preferred to remain anonymous. You know who you are, and we send our thanks!

photo credits

All the images in this book are by Eric Bean, the model comp cards (pages 92 and 155, Code Management), and Jen Bidner's portrait (page 4, Meleda Wegner).

special thanks

Eric Bean would like to give a special thanks to David Grilli for helping to coordinate many of the interviews in this book. He would also like to acknowledge Kathy Kamholtz (Davis), Steve McCullough, and Frank at Nexus Models for their help early in his career.

Jen Bidner would like to thank Dr. Fred J. Heinritz for his editorial contributions to the book. Both Eric and Jen offer their gratitude to Sandy Knight for her design contribution, and to Marti Saltzman, Kevin Kopp, and the rest of the editorial staff at Lark Books for their input.

1

the world of modeling

the modeling industry today is very different from even just a decade ago

today's model

"the age of the supermodel is dead. it doesn't exist anymore because the turnover is now so quick."

michael lange, micon worldwide

today's modeling industry offers a fun, glamorous, and rewarding career to many women, men and children. Today there is a much wider range of "looks," and there are many new opportunities for different types of models. Wholesome teens and "real people" are making excellent money in the Teen and Commercial Print Divisions. Mature, sophisticated women and men are sought for high-end clients. And the proliferation of the Internet culture and the globalization of the fashion industry has also allowed models of different ethnicities to be readily accepted.

On the flip side, we hear from most of our sources that it is now harder to make a living in the industry than ever before. One of the most commonly stated reasons was that the modeling industry has become oversaturated. There are simply too many models vying for too few jobs— meaning that, statistically, there is less potential income to spread around to each model.

Pay rates since 2001 have dropped, partly due to the economic ramifications of the September 11th terrorist attack, which caused many overseas clients to do their shoots abroad, instead of coming to the USA. Add to this the economic downturn that caused potential clients to tighten their budgets and no longer do as many lavish shoots with highly paid models.

To compensate, many agencies and models lowered their rates. Unfortunately, even after the economy rebounds, it may take considerably longer for the rates to rise. "Once a client gets used to paying a lower rate, they're going to be reluctant to go up again," reports one insider source.

last of the supermodels

The age of the "supermodel" is over. Today, more and more clients want new faces and fresh looks. "Models have become more disposable because new faces are currently so desirable," says Darryl Brantley, *Vanity Fair*.

"In the days of the supermodel, you could open up a magazine and see them in several different advertisements or editorials," adds Michael Lange of Micon Worldwide.

"The turnover with who is hot at the moment is really quick," adds Michael. "The average editorial model [a model photographed in magzines] works two or three seasons now, and then that person disappears off the map entirely."

"The way to establish a star is to continually have her face out there," explains Sam, an agent at Ford Models. "Clients used to want the familiar. Now they want new faces. New, new, new, new, new. You can't build a supermodel like that."

This type of short-lived editorial career makes it difficult for models to establish themselves in the "supermodel" category. These models of the past were able to reach that fame because clients *wanted* familiar faces. Today they want unique faces— and that means a constant turnover of new talent. Another era of supermodels won't occur until this trend for new and unique changes.

"The models that are popular today would never have gotten through the front door just a few years ago," explains model Amie Hubertz. "How clients pick their models is affected by a lot of different influences, most of them stemming from what is going on all over the world in the arts, culture,

"I think the biggest influence in fashion is MTV. the attention span of young people is short; and they have been taught to expect fast images and quickly changing trends." katie ford, ford models

and politics. These influences are going to be reflected in this business as much as anywhere else."

why the turnover?

Fast, fast, fast, change, change, change. The younger you are, the faster you expect information, courtesy of the television, computer, and Internet. It's hard for someone under the age of 30 to imagine that when model Carmen Dell'Orifice started modeling almost 60 years ago, there were no TVs. The only pictures you saw were in magazines or on a gallery wall.

Studies have shown that today's youth see exponentially more pictures than prior generations, so it is no wonder that they are more "visually savvy" and become more easily bored with imagery.

Don't believe us? Rent a DVD of an "old" movie like Citizen Kane. Though brilliantly done, every scene feels intolerably long to younger people who are used to the quick cuts and fast-moving action of modern movies and music videos.

This same need for fast, new images has spilled over into fashion editorials and advertising. The preferred "look" in models might be vastly different from one season to the next. As a result, it could cause last season's "top" models to struggle for work in the next year.

it's a small world

The globalization of business, the "small world" concept created by the Internet, and the simplification of international travel, has changed how models' careers are established.

"You don't have to travel all over the world anymore," explains Sam. "15 years ago you

had to go to Milan to get developed. That was just how the business was. Now you can stay in New York City and still become a successful fashion model."

Trends in photography (especially advertising photography) also affect the modeling industry. There is a lot of photography today that is very literal, as opposed to a fantasy. Gritty, closer shots of people who aren't necessarily classically beautiful. Instead, they show full-face pictures representing a certain *type* of person. The whole advertisement is about one face that represents a whole group of people.

How Americans "see" themselves also influences the modeling industry. "America doesn't think of itself as blond and blue-eyed anymore. We see ourselves as cross-cultural," says Katie Ford, Ford Models. "Asians and African-American models are

not considered the exotic models any more. They are the 'girl next-door.' "

competition

Cross-over competition from other industries is also affecting the income of models. "Writers, athletes, musicians, actors, and other celebrities are now wanting to be models," explains Sam. They are now competing for the magazine editorials and advertising jobs that were previously reserved for models.

Another issue that is harder to pinpoint is how models are developed. "The business is not as nurturing to youngsters as it was in my day," explains Carmen. "It's depersonalized. Nobody is grooming these young girls like they did in my era. Fashion today is all about making a buck."

six decades of carmen

fashion photographer and co-author Eric Bean recently had the opportunity to sit down and interview his friend Carmen Dell'Orifice, a legendary model who has worked in the industry for the past six decades. Beginning in 1945 as a 14-year-old, one of Carmen's first professional jobs was posing for Horst P. Horst for *Vogue* magazine. Almost sixty years later, today's youth know her as that "white-haired lady" in the Target television advertisements. In her own words, she shares her insights on the industry and her career:

I was a print model back in 1945, before televisions were in people's homes. The subway was a nickel and a quart of milk 10 cents. So what I've seen happen in that time! I had a lot to learn and I'm still learning all these years later.

I'd never dreamt of being a model. I dreamt of being a classical ballet dancer, and had a scholarship with the Ballet Russe. But I developed rheumatic fever, and was bedridden for a year as a child, which crushed that dream.

Modeling on the other hand was a total accident. I was on the 57th street cross-town bus in New York City, when the wife of a photographer for *Junior Bazaar* saw me

and told me to come in. We did some test photographs, and the next thing I know, my mother received a letter from them. It read: "Carmen is a very well-behaved young lady, but at this point she is totally unphotogenic. Perhaps we'll try in a few years when she matures."

Well, my Godfather and Godmother (who were both cartoonists for King Features) thought I didn't look so ugly. They had a friend who was staff writer at *Vogue* magazine (who later went on to become the president of Clinique), and she invited me up to *Vogue*. This was 1945 and I was just 14.

My first day at the *Vogue* studios, I posed for photographer Clifford Coffin. The next day I worked for Horst P. Horst. The next day I worked for a gentleman in his Army uniform and cap who turned out to be Irving Penn. Then Cecil Beaton. And I never seemed to stop. We are now almost sixty years later, and I'm 72 and still working.

I was so young and shy back then. And of course I had mad, *mad,* innocent crushes on Horst and Penn. Every time I had a sitting with Penn it would be a sleepless night before, waiting to get into the studio! They were all so dear and wonderful.

In 1945, Horst did a full-page photograph of me for *Vogue*. [Authors' note: This is the now famous museum image entitled *Camen's Face Massage,* which has even

"I saw a stack of vogue in 1947 with my picture on the cover and started crying because I thought I looked like a little boy. I even checked a second copy, hoping I would look different. that's how naïve I was!"

carmen, model

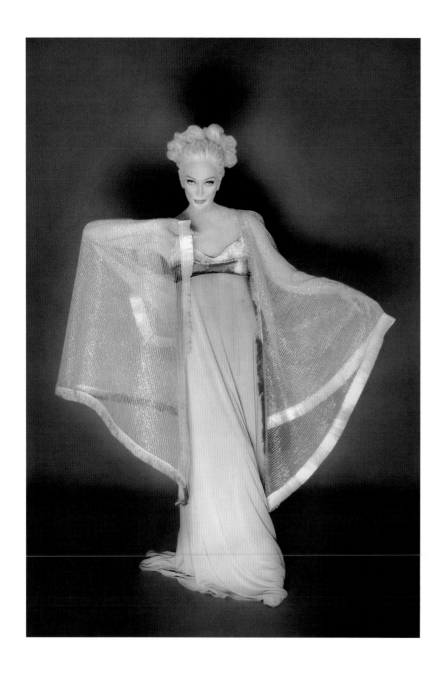

been paid homage to in Madonna's famous "Vogue" music video.] He told me to pretend I was a beautiful young lady who was being taken care of and being groomed for an event. I had to stay very still, because back then there were no flash and strobe lights, just big, hot lights.

There was no such thing as hair and makeup artists for models in the 40s. There were the Hollywood ones who did the movie stars with pancake, but people on street didn't wear this oil-based makeup. I didn't wear any makeup in real life, and put on my own for photo shoots. The editors would put my hair up.

Months later when the picture was published, I cried because I thought, "Now everybody really knows I have no bosom."

It was the same with my first *Vogue* cover in 1947 that had a picture Erwin Blumenfeld took. I distinctly remember getting off the bus and seeing a stack of *Vogue* magazines tied with rope next to an old-fashioned newsstand. I saw myself and again I just kind of welled up with hot tears. I hated it because my hair was pulled back, and to me it looked like a little boy.

I had felt so beautiful during the shoot with pink satin around me, and beautiful hair clips. I had thought it was going to look differently because I felt this wonderful softness. Instead, to me it looked ugly and hard. Of course I don't feel that way anymore!

You know what I did? I waited for the man to untie the rope and I picked up the first copy, because I hoped the second one would be different— but that's how naïve I was back then.

My mother had raised me on her own, and we were living on the fifth floor of a cold-water, walk-up apartment. Money was tight. We had to pawn the sewing machine

"here I was in my 40s..., with this nebulous color gray hair. I didn't mind *being* my age, so I didn't mind looking my age."

carmen, model

"it was 1974 and I was 43, when he said: 'for an old bag, you don't look so bad— let's go to paris and do some pix.'"

carmen, model

to pay the rent, and a lot of planning went into putting quarters into envelopes to pay the electric bill. But I'm grateful for that experience. A little hunger goes a long way in balancing how you think about money and what real life is about.

My first day of work as a model I made $60, and the second day I made $60. I worked five days straight like that. Our rent was $30 a month, so this was a small fortune to us.

Erwin Blumenfeld was very protective of me, and decided I should have good representation. So he brought me over to Eileen and Jerry Ford and said, "Look she's going to be on the cover of *Vogue* magazine and she'd very photogenic. Take her!"

Well, Eileen just seemed so mature and wise. Of course, she was only in her early 20s at the time, and had only just opened her model management office. She had been a model herself for Knox Hats and other things. More importantly, she had a fast-forward mind and saw that other girls at other agencies needed organization. She thought up this service to help models. In retrospect, she was just beginning a legendary career, and she invented the modern version of an agency.

Through my whole life, Eileen has been the most magnificent guide. She's someone I've always looked up to. She reinforced certain types of ethics and family values, and helped me imagine what life could be.

You have to remember that World War II had just ended and the country was coming out of an austere period. Rationing was ended and bans on exports were being lifted and a whole new era of feminine glamour was starting. Suddenly you saw a Dior waistline where before it was only uniforms. Austere walking shoes were replaced by Ferragamo high heels. We no longer had to wear garter belts and precious silk stockings because the technology of nylon parachutes gave way to pantyhose! It was a wonderful, liberating time.

Everything in business was handwritten or typed without computer. I didn't even have a telephone back then, and they used to have to send runners down to my apartment if I had a job and leave a note under the door.

I worked almost non-stop until my third marriage in 1963 when I called up Eileen and asked her to book me out. She said from when to when? I said *forever*, and she laughed. *She* knew better.

For the next 15 years I concentrated on raising my daughter, and took only occasional modeling work for friends.

"the concept of an older, sophisticated model was embraced..., because our society as a whole is aging."
carmen, model

Following my divorce, I started thinking about a career as an editor or model booker. After allowing my career as a model to wane, I really didn't think it would start up again.

Here I was in my 40s, with my hair starting to gray! But unlike the other women of my generation, I decided not to dye it back to its original dark color. It just looked too harsh against my skin. So I lightened the rest of my hair to blend it in with the gray.

I was ahead of my time for a very practical reason, not to make a statement. It was aesthetically more pleasing to me to have this nebulous gray color hair. I didn't mind *being* my age, so I didn't mind *looking* my age.

In 1978 I ran into photographer Norman Parkinson at a book opening. He was a photographer who didn't wax or wane with the tides of the business. He was one of the first photographers to work the world, and he was still on top.

I will never forget the words he said when he saw me after all the years: "For an old bag you don't look so bad. How about doing some pix? Let's go to Paris."

So I went to Paris with "Parks" and we did six pages for *French Vogue*. When he came back and showed them to *Town & Country,* they kind of said, "*That's* the look that has been missing." The concept of an older, sophisticated model was embraced wholeheartedly. From that time on it slowly built, because our society as a whole was aging.

My entire career was like that. I was atypical of what the marketplace was describing, but people somehow couldn't resist me for a shot here or a shot there.

1991 was a dark period for me. Through the best of introductions, I had a money manager who lost every penny I had saved and I was now just over 60. I was faced with no money for retirement. I sold my silver service at Sotheby's so I could pay my bills. And I felt lucky that I had something substantial like that to sell.

I take full responsibility for being too frail and afraid to find out enough about the marketplace, and giving my money totally over to another person. It seemed like a good thing to do when I didn't know anything about money. But my outlook today (and my advice to others) is to educate yourself about the important things. If you don't know about something as important as your own finances, you need to find out.

My career in the last seven years has been a surprise for me. You never know what is around the corner. I must have wished never to be bored. And I'm always willing to try something new.

I've recently been in on the runway in fashion shows for top designers, including Isaac Mizrahi, Cynthia Rowley, Terry Mugler, Jean Paul Gaultier, and John Galliano.

Some of my favorite images from my career have been taken recently, including an image in an evening dress that Eric Bean took. I was pulling out the rollers in my hair, and he told me to stop, and we took the picture like that. I could see in his eye that he had something great, so I trusted him and we become collaborators in the moment.

My latest work is a television advertisement for Target stores. I've always considered a model to be a silent actress, so the transition was natural.

Isaac Mizrahi helped in the redirection of Target, and brought me in as a model. He has a very innate sense of marketing, and he has the perspicuity to understand the aging society. His creativity stems from a mindset about living, and it encompasses every aspect of his life.

The sum of my career is that extraordinary things happen if you're open to them. I've always loved clothes. I've always loved the silent acting side of modeling. So I hope to keep rediscovering myself.

I haven't convinced myself yet that I'll be the first person to live forever, but I want to live happily in my skin, and not fearfully. I want to die with my high heels on!

2
modeling specialties

there are numerous specialties for men, women, and children

freelance vs. agent

"if you just want to [...] modeling on the s[...] don't need an age[...] you have professi[...] aspirations, an age[...] virtually a requiren[...]"

the first concept in modeling that must be addressed is the difference between full-time professional modeling in a major market (like New York City, Chicago, and Los Angeles), full-time professional modeling in smaller cities, and the concept of "freelance" modeling.

The bulk of this book is aimed at the top tier in modeling— getting an agent in New York or another large city (the "primary markets") and landing the top paying and most prestigious clients. To become a top model, you will need to go to one of these major markets (New York City being the largest) and work with an agent. These topics are covered extensively in Chapters 4 and 5.

That being said, there are plenty of models working in medium-sized cities who make a comfortable living. These are full-time professionals who have agents, and work in cities like Charlotte (North Carolina) or Rochester (New York). However, you probably won't see them in major magazines, and it's doubtful you'll

know their names. Some may be squeezing out a modest living, while others are pulling in six figures. An agency in a primary market may learn about a model in a smaller city and bring them into their fold, not unlike a Minor League baseball player being called up to play in the Majors.

The third category is the freelance model. This is the model who does not have an agent. This model lives in a small city that has no or few agencies. Or they are a person still in school, staying at home as a housewife or mother, or working in a job that would allow occasional days off for castings and jobs. It can also be a beautiful woman or handsome man who for some reason has not been able to sign with an agency, but still wants to pick up occasional modeling jobs.

Freelance models rarely make enough money to live on. You might earn some nice supplemental money— $100 here and there— but few can count on paying

their rent, [...] the income[...]

Freelance m[...] ego-gratifyi[...] describe the[...] and occasic[...] extra mone[...] young marr[...] modeling fc[...]

Unfortunate[...] small cities[...] swimsuit m[...] enough job[...] men, and cl[...] The small m[...] which mear[...] sometimes [...] on smaller [...]

"if you decide to freelance, be realistic in your expectations. the best jobs are usually through agencies."

hobby or job?

If you want modeling to be a career, you really need to focus your attention on getting an agent because most of the jobs (and virtually all of the high paying jobs) are only through agencies. An agency can help you get a steady stream of castings and jobs. If you're spending all your time trying to promote yourself to potential clients, when are you going to do the actual paying work? An agent frees you up from this.

However, if your goal is to just have some fun, and do some modeling on the side then you may not need an agent. In a small town, you could probably call and meet the person at a corporation in charge of hiring models for advertisements and annual reports. If the corporation or industry is large enough it may have enough modeling needs to provide full or part-time work for a number of models. You might also be able to secure occasional work off an Internet "agent" or Internet portfolio website like www.onemodelplace.com or www.models.com.

reality check

The trick is to be realistic in your expectations. Don't fall into the freelance modeling trap of thinking a few small jobs are necessarily going to turn you into a full-time model. If you have a "regular" non-modeling job, don't be tempted to call in sick for castings, and then again for the shoot. It's just not worth risking your job for what amounts to a hobby.

Realism about modeling requires that you "do the math." A single $200 swimsuit job might sound like a huge amount of money if you're a working a $10/hour job. However, you have to divide that $200 not just by the hours of the shoot, but also by the time spent attending and prepping for the casting, *plus* the castings you went to where you didn't get the job, and any expenses you had (such as printing promotional materials, or subscribing to a modeling Internet site). Suddenly the hourly wage on your "regular" job might start sounding great.

freelance specialties

Several specialties are dominated by freelance models. The category of Swimsuit models, for example, has only a few reasonably well-paid catalog, calendar, and editorial jobs in the *entire* country. The rest pay negligible or no money.

In addition to competition for these jobs from models who have agents, there will also be thousands of pretty girls wanting the job who are either too short or too large-chested to be with a major agency. Therefore, if you aspire to become a "Swimsuit Model," you should probably look upon the category as more of a hobby or side business, and not a full career.

The same is true with babies and children. *Everyone's* baby is beautiful! So the few jobs there are go at surprising low rates. In the major markets like New York, Chicago, and Los Angeles, a lot of the baby and child modeling is done by the children of models. Parents who are models already know the business, and already work a schedule conducive to casting calls (see pages 44-49).

So-called hair models are also a myth. An advertising or editorial client needing a "hair" model will use a Women's Division model who happens to have the right style of hair. It simply isn't cost effective for an agency to have a model who is limited to just hair. The hobby hair model may get "jobs" modeling for the local salon, but the payment is usually the hair cut itself.

Unfortunately, the worst predatory con artists will do their hunting in the freelance model markets, taking advantage of the hopes and dreams of young girls and mothers. So keep your eyes open and read pages 106-111 for hints on avoiding potential scams.

women's division

"in the 1970s the swedish look was the norm, and everyone else was *exotic*. Today, the girl next-door is african-american, asian & latino."

katie ford, ford models

t he Women's Division in an agency is usually its largest department. A big New York agency might have over 200 people in this division alone, from girls in their teens through women in their 30s. Some agencies (especially smaller boutique agencies or smaller markets) combine the teen, classic, and commercial into one department. (See later sections of this chapter for specifics on these specialties).

The biggest market in the country for women models is New York City. To get in a New York agency, you will need to be the best of the best. The same is true of other primary markets, including Chicago and Los Angeles. Medium sized cities (secondary markets) include Atlanta, Boston, Dallas, and Miami.

In a primary or secondary market, you will also have to meet the rigorous size parameters, which are approximately 5'9" to 5'11" in height and a Size 0 through 6, with the vast majority in the Size 2 to 4 range. (See pages 58-61.)

When you start at a young age, such as 16-years-old, you may be put straight into the Women's Division, or you may spend time in the Teen Division. It depends on your individual "image" and your particular talents— rather than your actual age.

Young models in the Women's Division tend to have an "edgier" look that makes them appropriate for high fashion work, such as magazine editorials. If you look more like the "girl next door," then you'll probably work in the Teen (see pages 36-37) or Commercial Print Divisions (pages 38-41).

Ten years ago, the Women's Division was further divided with a Runway Division, but today, most runway models also do high fashion and other work.

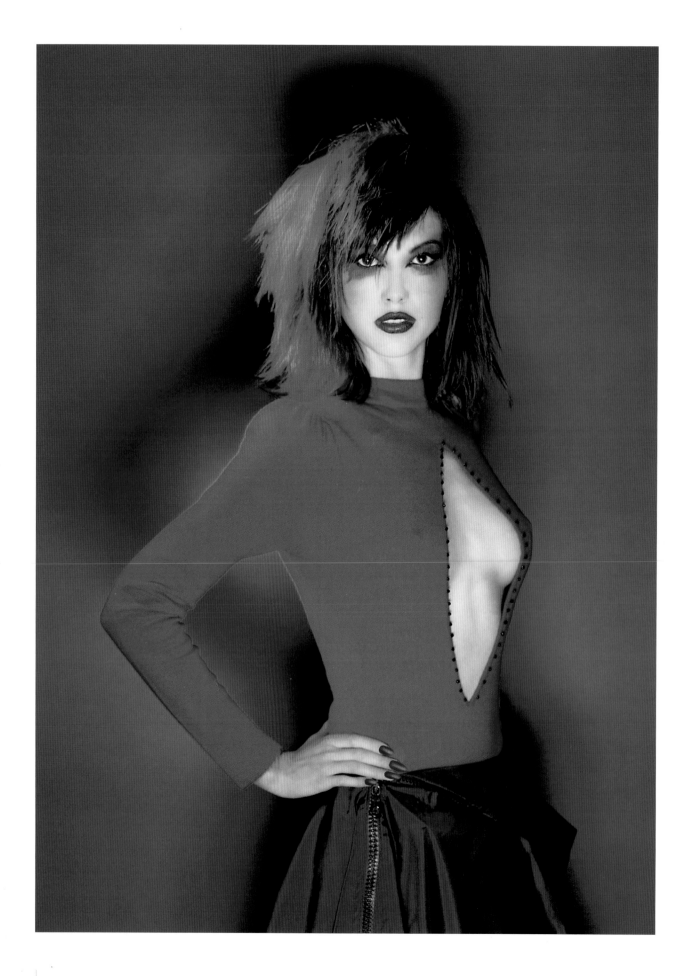

runway

"runway models are freaks of nature! how many women are naturally 5'11" and size 2, while still looking elegant?"

to the general public, runway modeling seems like one of the more glamorous specialties. Young girls playing 'dress-up' with their friends are as likely to pretend to walk down a runway modeling clothes as they are to mimic their favorite singer. However, it is only a *very* small segment of the modeling industry, and not at all what most people outside the industry envision.

Model Jodi Kelly gives a reality check: "Yes runway work is glamorous, but only for the 30 seconds you're on the runway. Once you step backstage, all the glamour instantly disappears. At lightning speed you're stripped naked, new clothes are put on you, makeup is changed, earrings are pinned into your ears, your hair is re-combed, and then you go out again for another few seconds."

In normal fashion and commercial print photography, there is a lot of "down time" when makeup is being applied, hair and styling is finalized, lighting is set-up, creative decisions are being made, etc. However, with runway work the pace is usually frenetic. Not only do the models have to change outfits and makeup quickly,

but they are often booked in multiple shows on the same day.

"Even makeup is done at lightning speed," states makeup artist Cyrus. "For fashion, I usually take 2 hours. But with runway, I'm lucky to have 20 minutes—and that includes cleaning off the makeup from the last show."

runway specs

The "ideal" runway model changes with the industry, as fashion trends change. The preferred size is determined by what size the designers are cutting their sample clothing to, because the model must fit into them.

Using the 2004 season as an example, the ideal female runway model was 5'11", Size 2 (or even Size 0), and weighing about 100 pounds. This differs radically from the 1980s when a size 6 was the norm. By the 1990s it had dropped to Size 4.

Runway specialists are built a little differently than beauty models or print models. That's because with a studio photograph, you can work with lighting, lenses, makeup, and retouching to make them appear taller, shorter, slimmer, or more beautiful. But a runway model has to look in real life like what she would look like in a

photograph because runway shows are live and the photos are more photojournalistic.

Runway models tend to be more exaggerated and thinner. They have more exaggerated facial features and a more elongated body so they can show off the clothes better.

Most runway models are also quite young, usually from 16 to 21. "When a girl is 16, her skin is flawless and tight," explains runway booker Maurico Padilha. "Her face is stunning at that age. She doesn't look tired. She can do anything she wants and she'll still look great.

"It is expensive to retouch a photo, so anyone who hires a model wants a girl who is as flawless as possible. They can pay her once, instead of having to pay more later to retouch flaws on another model. In the long run they'll save a lot."

"Then it becomes a catch-22," adds Mauricio. I can't hire older models because they'll look awkward and different walking down the runway next to 16, 17, 18 years old. The only ones that can pull it off are those that are already famous. That's because the people looking at them aren't just looking at them as models—they're celebrities. That's the only way I'll use an 'old' girl. "

Even Maurico admits that if they're too young, they might not have the experience and confidence to walk the runway well.

Model Amie Hubertz concurs: "When I first started out, I went straight to runway work, because I was young, tall and skinny— but I always felt like a fraud. I wanted to say, 'Just because I'm tall and pretty doesn't mean I have the chutzpa to be walking down the runway like a sexpot. I'm just a kid!' Luckily I had an agent who really listened to me, and we stopped doing it."

buyers' shows

It is important to note that there is secondary runway work for models who work the "buyers' shows." The runway shows we all envision (the glamorous photos and video clips that are shown in the magazines and on TV) are the spectacular events put on for the press. After (and sometimes before) these big shows, are smaller runway shows put on for fashion buyers— the people who actually place orders for the merchandise in stores.

For these smaller shows, the designers often use models who are larger in size with more curves. Though still a Size 4 or 6, they better represent the potential buyer. In the main show, a skirt might be shown on a topless model in high heel shoes with a wild hat and outlandish makeup. The same skirt at the buyers' show would be shown in different colors, and normal accessories.

These "buyers' shows" may not have the glamour and prestige of the press events, but they can provide steady, lucrative work for the right model.

"I had six straight weeks of work in Milan, doing two or three shows a day for Prada," explains Jodi. "They didn't use me in their main press event, but for presentation to the actual fashion buyers, Prada liked the fact that I was blond and had a more womanly shape."

that special walk

Both Michael Lange (Micon Worldwide) and Maurico agree that nobody can teach a model how to walk, because gracefulness comes from within. It can be honed, but not taught. The model has to watch, practice, and gain confidence.

A runway walk is not the way any person would walk down the street. It's a performance. It should be a seamless presentation. The model must be so smooth and graceful that she is almost unnoticeable, and what you are looking at is what she's wearing and the overall presentation of the clothes.

"A lot of girls start out too young and they're unsure of themselves. But a year later they'll look great. They're more confident with their bodies and it shows," explains Mauricio.

Models have to look good from the front, back, and side, because the runway is viewed in all directions. "You'd be surprised that a girl who walks amazing from the front, looks terrible from the side," reports Mauricio. Shows are also videotaped, so they have to look good moving as well as in still photographs.

The walk also changes with the fashions. In past years, a sexier hip-swaying look was preferred. A few years ago, Armani started a more technical look without smiles or emotions, and this has spread into the current trend of "beautiful robots." Next year, it could be different.

For men, the runway walk is not nearly so important. Michael Lange hypothesizes that this is because women's clothing tends to be cut so it moves and flows over the body, making the movement of the walk paramount.

men

"there is a huge demand
for men in their 30s and
40s who can portray the
successful executive."

sam, ford models

the field of male modeling differs from female modeling in that there are fewer divisions. Most agencies have a Men's Division that combines Fashion, Runway, Commercial Print, and Classic specialties. Hence the models in this division can range from 18 to 65. Even so, most Men's Divisions have fewer models than the same agency's Woman's Division alone.

In the New York City and major markets, the size requirement is 6'0" to 6'2" (with an occasional 6'3" man sneaking in). Even at this height, they must fit into a 40-42R or 40-42T jacket. The most common waist size is 32", with a 33" inseam.

The men tend to be nicely toned, but not too muscled up. Like the women, this is so that they can fit in the sample clothing. Even body models like Todd Riegler (see pages 50-53) can't be too muscled, because large biceps and huge thighs will pull at the seams of the clothing.

There are exceptions of course. Everyone likes to point to the Abercrombie & Fitch

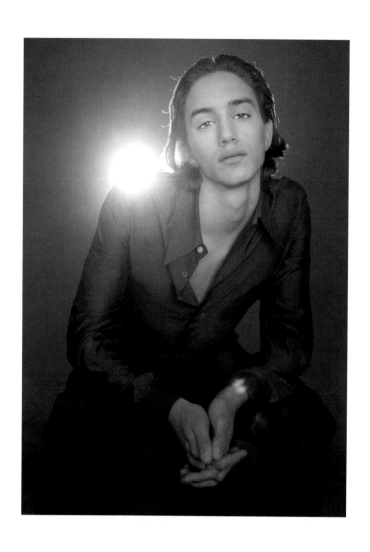

"in the men's division there are no supermodels. nobody in the men's division is *not* disposable."

michael lange, micon worldwide

catalogs as an example. But after working for this single client, the model would probably have to work with a physical trainer to drop in muscle size if they wanted to get regular work in fashion and commercial print.

Men with bigger, bulkier bodies tend to do best in the catalog oriented cities where they're showing off more sportswear. These include Chicago, Miami, Los Angeles, and Berlin.

Traditional cutting edge fashion work is generally done by young models. Here again, like the women, the preferred look changes with the industry. Some years they want a frat boy look, next it's the hip-hop look.

With the exception of the rare "male supermodel" fragrance contract, these younger models tend to work the prestigious but lower paying fashion magazine jobs. As mentioned in Todd Riegler's story on pages 52-53, modeling for a cover of a major magazine like *GQ* may pay only $150, while a good Commercial Print day rate might be $4000.

The huge headline-making contracts for models are most often for women, especially from fragrance and cosmetics companies. It's a matter of economics. Men don't shop for clothing and beauty products as much as women, so the manufacturers don't spend as much money advertising these same products for men.

older models

There is a huge market for male models in their 30s and 40s to play the role of the executive or the dad. In fact, often the most consistently high year-round money earners are in this category, especially if they tap into the lucrative "suit market." There are plenty of 30 and 40-year-old men in the primary (and even secondary) modeling markets who pull in six-figure modeling salaries.

Wrinkles can be a plus in male modeling because it represents maturity. However, these wrinkles cannot be the type caused by bad health, smoking, or poor living habits. The skin must be glowing and healthy beneath the wrinkles.

Facial hair trends tend to come and go, and your agent can help create the right image for you. Body hair preferences change, but usually the hairless chest is preferred in the American market.

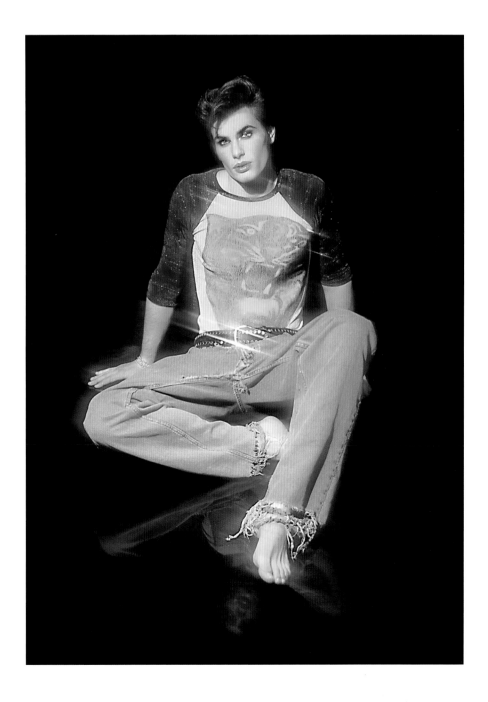

teens

"don't confuse the teen division with the age of fashion models who happen to be in their teens. it's an entirely different look and entirely different market."

n the past decade, a new division has opened up at many large agencies to meet a growing need. The Teen Division caters to clients who need wholesome, "real" looking teenage models.

The Teen Division has both male and female models. These are people who don't look like "supermodels" or "glamazons." They're often trademarked by a wonderful, friendly smile. They are models who look 15, 16, and 17 years old. Basically, they're just a more attractive, idealized version of the everyday teenager.

Most Teen Division models are slim and more normally proportioned than high fashion models, such as a Size 4 or 6 girl. Slightly shorter heights are acceptable, especially if you're expected to grow as you mature. This opens the door to some girls who are only 5'7" or 5'8", and boys who are 5'11".

Teen models are usually photographed with minimal makeup or even clean-faced. And they generally have simply-styled hair.

"There is some overlap between the child and adult market," explains Katie Ford,

Ford Models. "But the market for teen models grew when the number of fashion, news, and gossip magazines targeted to teens expanded."

These magazines include *Cosmo Girl*, *Seventeen*, *Teen*, *Teen People*, *Teen Vogue*, and *YM*. Other common Teen Division work comes in the form of junior catalogs. Some teens work their way into the high fashion market as they gain experience or their looks change. Others stay in the Teen Division for years, often into their twenties, if they look young enough. Lindsey Kraft has been a successful "teenaged" model for over seven years because she looks the part even though she is a college graduate.

"I got to go to ten proms last year," she jokes as she counted up the prom-related editorial pictures or catalog shoots.

Another successful teen model, Frankie Dell, didn't stop modeling in prom tuxedos until he was almost 40, because he had a young, smooth-faced look.

"In person, I looked 30, but on film I looked 20 at most," says Frankie. "I couldn't have pulled off the 'executive' look at the time, but I got plenty of work as the oldest teenager in town!"

right
Teen models must have a
wholesome look. They
tend not to look as
"edgy" as high fashion
models, who may also
be teenagers.

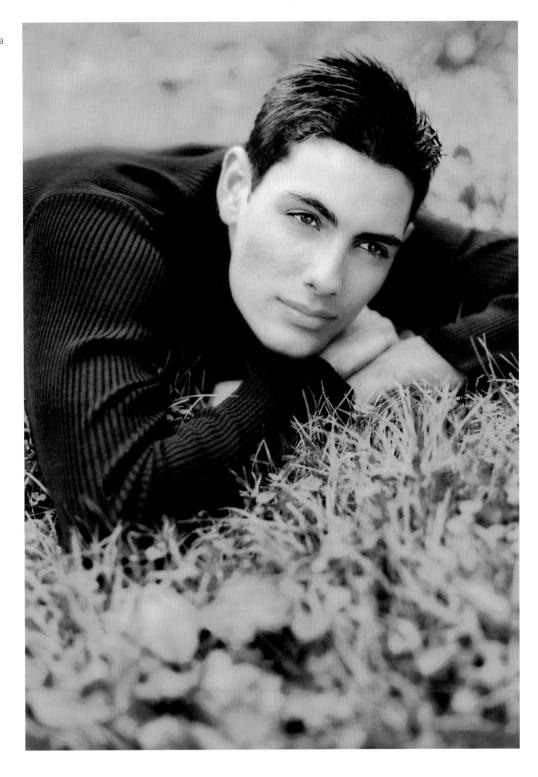

"as a teen model, I got to go to
ten proms last year!"

Lindsey Kraft, model

commercial print

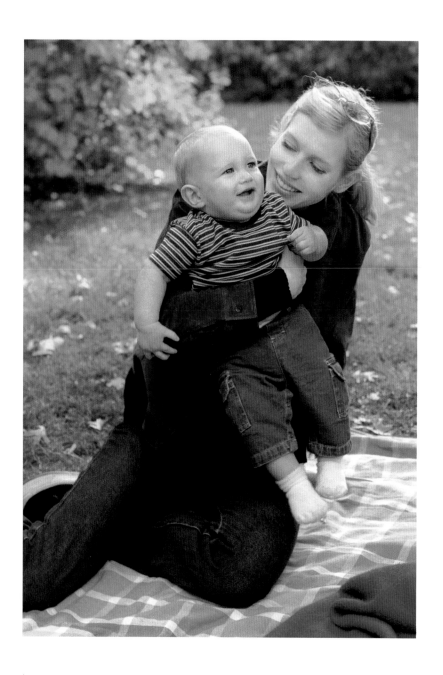

One of the less glamorous but more lucrative types of modeling is Commercial Print. It is a huge market, especially in the secondary and tertiary markets, including Chicago, Dallas, and Atlanta.

Because it is perceived as less glamorous than High Fashion and Runway work, some aspiring models are offended when an agent tells them they're "more commercial." It means they probably don't have that edgy, current look needed for fashion. But it also means that a very big door has been opened— one that often leads to a much longer career than the average fashion model.

"If managed correctly, a Commercial model can start in her teens and work steadily through her fifties," says one agent.

Commercial Print clients are any company that has advertising needs for a product or service that is not fashion driven. This includes advertisements for cars, medications, or insurance policies.

"commercial models are a prettier,
more idealized version of your mom,
your dad, the girl next door."

jodi kelly, model

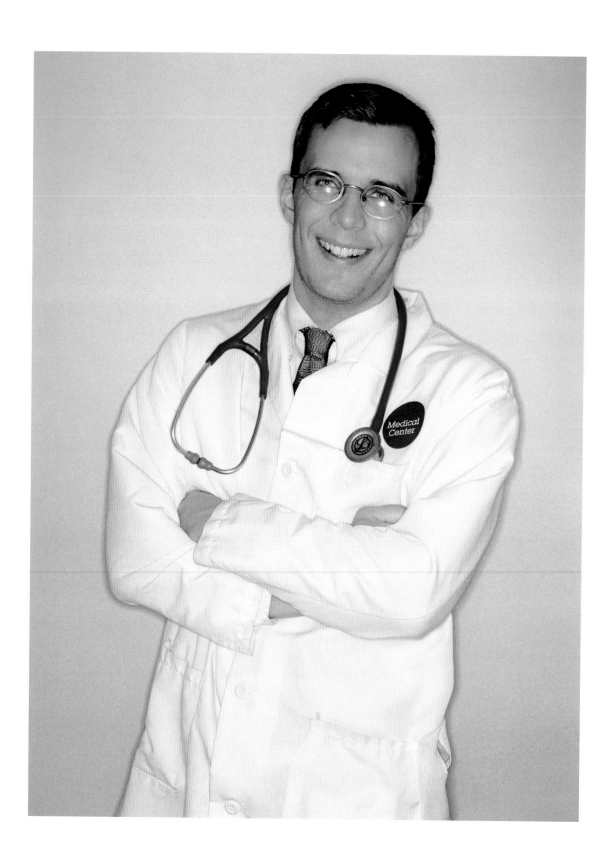

"a commercial
print career
that has been
managed well
can last for
decades."

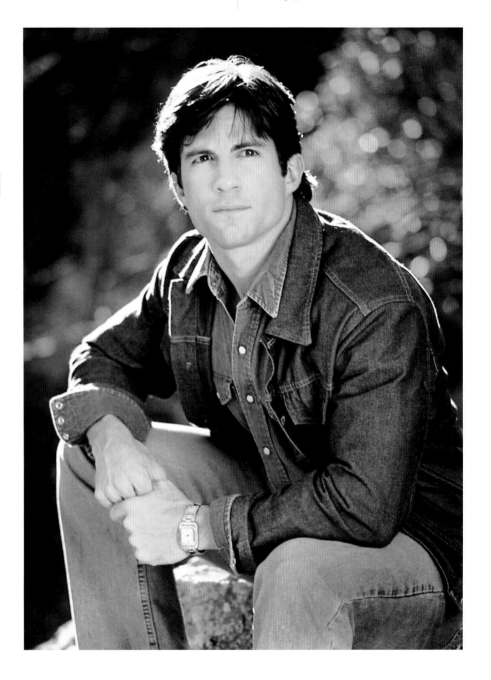

"Commercial models can depict the mom, the dad, the corporate executive, the flight attendant, the neighborhood pharmacist," explains Jodi Kelly. "They're models who look like average people — only a prettier or more handsome version."

The division can run the gamut from teenagers to 80-year-old grandparents. The size requirements that are so rigid in the Women's and Runway Divisions are much laxer in this division. You'll find more Size 4 and Size 6 women, and you'll also find more opportunities for women as short as 5'6". However, if you are shorter than the preferred 5'9", you must still be extremely well proportioned.

"There is a glut of 18 year old girls wanting to be a model, whereas the perfect 30-year-old model is harder to come by," reports one agent.

This is compounded by the problem that many fashion models try to look younger as they age. They are still trying to go for a sexy look, when they might find more work if they allow themselves to look their age and go for the classic "Mom" jobs.

There is great opportunity, especially in the secondary markets, for mature men of all races in their 40s and 50s, particularly those with an executive look.

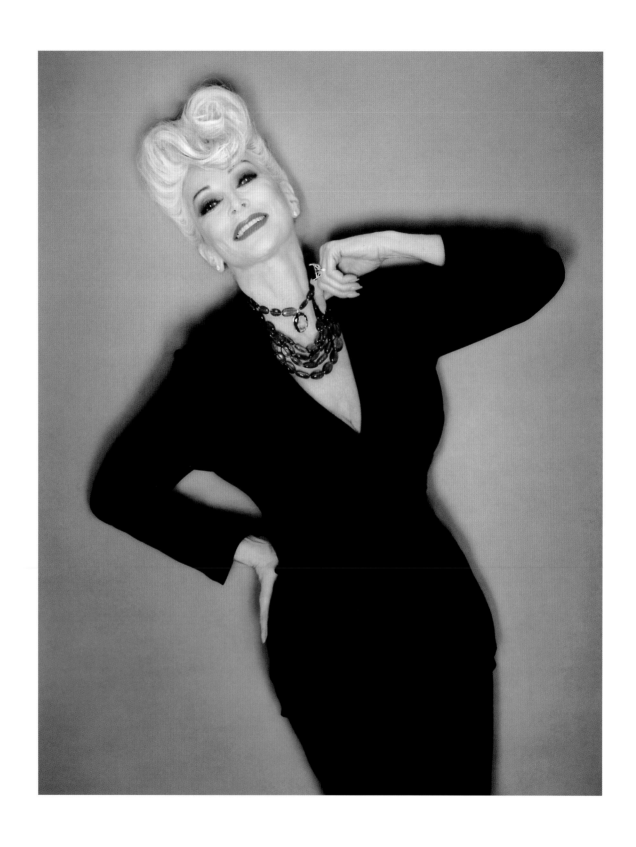

"Many jobs in the classic division come from high-end (and high-paying) luxury clients."

"there are three high points in a model's career— when she's young and edgy for fashion, when she's the 'mom' for commercial print, and when she reaches the classic division."

katie ford, ford models

classic

the Classic Division at most agencies is populated by women 40 years old and up. It is not the grandmother baking cookies (this model would be in Commercial Print). It is the sophisticated, older woman. It is the silver-haired, elegant, woman dining in Palm Beach.

Models in this category can look their age and have wrinkles. They include famous models, such as Carmen Dell'Orifice, who have revived their careers a generation after raising their family.

"The biggest market after a model is in her twenties is when she's in her fifties," says Katie Ford, Ford Models.

Many of the jobs for Classic Division women come from the high-end (and high-paying) luxury clients. This includes automobiles, vacations, retirement-oriented products and services, and pharmaceutical advertisements.

As people mature, their buying power often increases, and the advertisers target them with similarly aged models.

Some women drop out of modeling in their late twenties and thirties for a decade or two to take care of their family or pursue another career. Suddenly, with graying hair, they find themselves very much in demand again as models.

"The short career has changed," says Katie, but adding that it goes in waves. "The amount of work available to her when she's thirty is *less* than what she had in her twenties, and *less* than what she will have in her fifties."

Carmen is delighted that she is now very much in demand as a runway model at the age of 72 (see pages 14-19 for her story). Carmen's clients range from luxury car manufacturers to Target stores. Model and actress Lauren Hutton works a wide range of jobs, from J. Crew catalogs to her own line of makeup.

babies & children

"many baby and child models have parents who are also models, because they are already savvy about the business and have schedules conducive to casting calls."

top industry insider

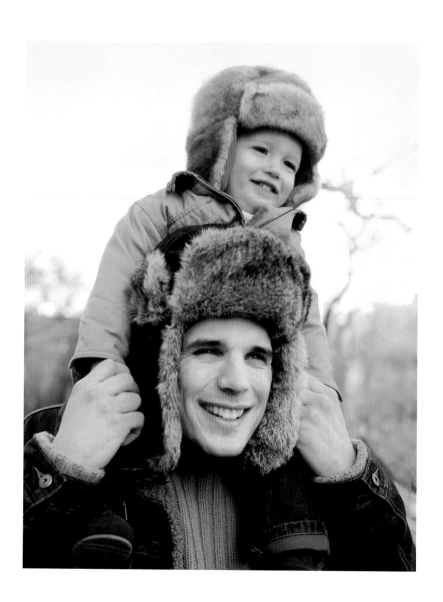

Children's modeling is generally grouped into infant/baby, toddler, and children up to about age 12 (in looks rather than physical age). Because children change so much in appearance as they grow, almost every modeling job requires a live casting since pictures are outdated almost immediately.

There are definitely jobs out there for babies and children, unfortunately there are far more willing models than openings. After all, the saying that there is "no such thing as an ugly baby" is fairly close to the truth! In any business, when there are more qualified people vying for a job, the paychecks drop lower. In this field, they drop so low that it becomes hard, if not impossible, to support a family on the income of a baby or child model alone.

Because of the low rates in baby/child print modeling, this type of modeling really becomes more about the ego gratification

right
Today's children are embracing new technology more than ever. Therefore it's not surprising that a lot of advertisements and brochures show child models using computers, picture phones, and other high-tech items.

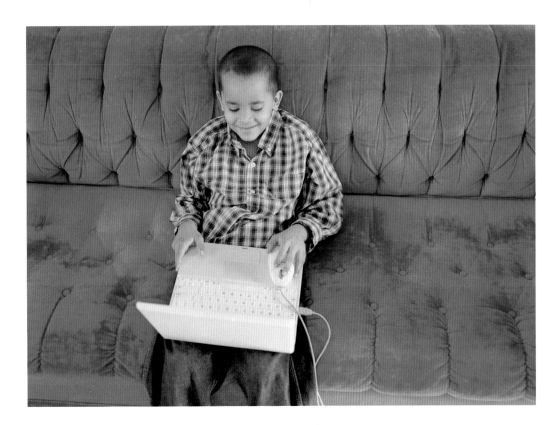

of the parents than for income. Most baby and child models fall into the freelance modeling category (see pages 22-25) for this reason.

The only real money hits if the child is able to segue into television or movie work. Here, the paychecks can be considerably higher.

Model Jodi Kelly's son was chosen to pose for a Baby Gap advertisement that ran for five pages in magazines like *Martha Stewart Living*. He was paid about $700 total for unlimited worldwide usage of the photos. This might sound like quite a lot of money at first. However, had it been his mom posing and selling similar rights, the paycheck would more likely have been $50,000 to $80,000. Hence the child's rate was about one percent of the mother's!

Additionally, the parent needs to take into account the cost of all the hours spent

going to castings at which their child did not get the job, and all the expenses (like babysitters for the other children and travel expenses) related to it.

It is interesting and not surprising that many child models are the offspring of adult models. It is not just genetics. The parents already know the routine and the clients, they are savvy about the business, and they already have a schedule that allows them to attend casting calls.

Attending castings is very time consuming. The "normal" parent simply doesn't have the time to stop what they are doing to run into town for a casting.

"Children are cast as much for the parent as the look of the child," says one inside source. "There is nothing worse than an overbearing parent on set. So we watch to see what the parents are like at the casting. Are they hovering over the child constantly or causing a commotion? If so, we won't

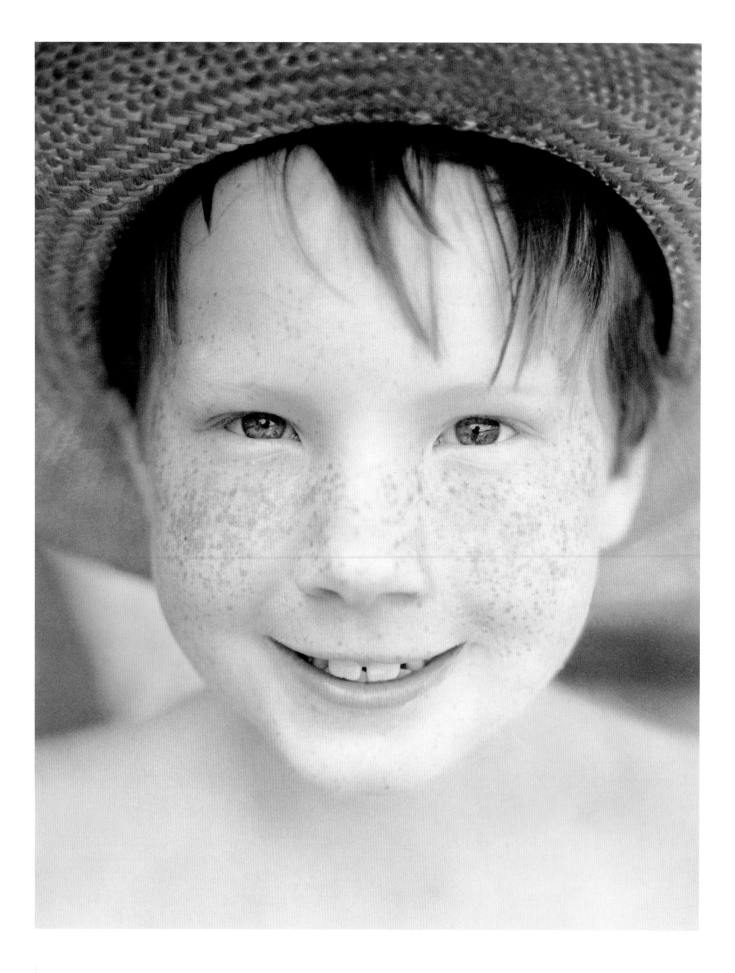

"children change
almost daily, so
you don't want
to spend a lot
on a photo
that is instantly
outdated.
snapshots in
your backyard
are all you
need or want."

even consider hiring them no matter how great the kid is."

"On more than a few occasions I've had a child who was beautiful and a pleasure to work with, but their mother was a nightmare," says David Grilli, Code Management. "Even though the model was working and working well, the clients didn't want to book them anymore because the mother was so bad. When that happens, the agency can't keep them."

parental concerns

In addition to having discretion and business savvy, parents need to keep their children's best interests in the forefront of their mind. Are you doing this because *you*

"children are cast as much for the parents as for the look of the child. there is nothing worse than an overbearing parent on set."

top industry insider

a warning from the FTC

The Federal Trade Commission has issued this special warning to parents of infants, toddlers, and young children:

You have a beautiful baby! Think your child is model material? Bogus talents scouts do. And they'll gladly set up a professional photo shoot to allegedly help you get modeling and acting jobs for your tyke. Of course, they don't tell you that the market for infant models and actors is very small.

What's more, because an infant's looks change quickly, the photos become outdated. In truth, few infants are marketed with professional photos. Legitimate agents, advertising agencies, casting directors and producers generally ask for casual snapshots of infants that have been taken by family members or friends.

want to be the parent of a model? Or is this really something your child will enjoy or learn from?

Some babies and kids eat it up, and enjoy every moment. For others it is pure torment with little benefit. There is a lot of rejection in modeling (see page 157), and while it is difficult for adults to handle, it can have extreme consequences on the self-esteem of certain children. You need to know your child, and watch them vigilantly.

On the flip side, a 10-year-old boy who looks seven, or a 13- or 14-year-old girl who is 5'11" may feel awkward and out of place at school because they are so different than the rest of the kids. But when this youthful look or exceptional height helps them become successful in modeling, it suddenly wins them prestige with their peers (rather than endless teasing), and helps them gain more self confidence.

If you do decide to proceed with a modeling career for your child, keep the atmosphere light and fun. If it is not a positive experience, your child will not succeed in the long run. A child forced to a photo shoot will not perform well for the camera.

Also analyze the effect it will have on your other children and your spouse. It may require you to spend considerable time away from the home during castings and photo shoots.

body models

"you need to be very comfortable posing nude or nearly nude, because your confidence (or lack thereof) will show in the pictures."

todd riegler, ford models

today body modeling is a small specialty market, primarily for male models. These are men who are more muscled than the average model. (Most female "body" models are taken from the general Women's Division pool.) The jobs are varied, from magazine editorials, to cologne advertisements, calendars, sportswear catalogs, and sleepwear.

However, it is important to note that "big" is a relative term. "I still need to fit into a size 40R to 42R suit, or perhaps a 40T to 42T," explains Todd Riegler, a body model represented by Ford Models.

Male body models are more bulked up than the average Men's Division model, but they are by no means Mr. Universe. Rather, they need to be very proportioned for their size. And they are still subject to the general height requirements of the Men's Division. (5'11" to 6'2").

Because their faces are often shown in the pictures, male models can't get away with physique alone. They must also have a handsome, photogenic face.

In addition to the health tips given in Chapter 3, a body model has the extra burdens of keeping their body sculpted, and then knowing how to show it off for the camera. They have to practice different poses, and learn how to accentuate different parts of the body. This is a skill that separates a successful, professional body model from countless other handsome, muscled men.

"I've had to learn how to look relaxed but actually be posing," explains Todd about skills he's learned through experience. "You really need to know your body and how it will look to the camera."

For instance, do you look better when you exhale or inhale in a certain pose? Todd accredits this attention to detail as a primary factor that allowed him to be chosen for a *GQ* magazine cover over hundreds of other prospective models. (See pages 52-53 for details on this shoot.)

"At a callback for the *GQ* cover shoot, they thought I was breathing in a lot of air while posing and commented on it," recalls Todd. "I informed them that I was actually exhaling— an old body builder trick to tighten the abs significantly. Then I demonstrated it."

The client and the photographer didn't know this trick, and couldn't believe what a difference it made on film. In a competitive business, this kind of attention to detail gave him an edge, and possibly won him the job. So you really have to be attuned to your body and practice in front of a mirror.

the *GQ* story
One of the high points of Todd Riegler's career was when he was selected for one of the few non-celebrity covers that *GQ* magazine (*Gentlemen's Quarterly*) has run in the last 20 years. He recounts the story in his own words:

This is one of those rare instances where I found out about (and booked) a casting before my agency knew about it. I'm very proactive in networking, so all my friends— and even acquaintances— know I am a body model looking for work. A friend at

Conde Naste Publishing told the editor of *GQ* about me, and they called me for the casting.

The casting was a total cattle call. *GQ* is one of the more important and prestigious magazines, so everybody wanted the job. There were probably 300 people at this one casting.

They had a very detailed sketch of the pose they wanted, and it was an extremely difficult one to hold. Because so many of the other body models had difficulty holding the pose, they held a second casting, for which they brought in dancers and yoga professionals.

At my casting, they had me get into a Speedo and then copy the pose while they took a few Polaroids. This was an example of a casting where they had a very clear picture of what they wanted, and they were looking for the perfect person who could recreate the sketch the creative team had developed.

I really wanted this job, so I wrote a polite thank you letter to the casting director. I also mentioned in the letter that I knew it was a difficult pose, but I was confident that I would be able to do it for the shoot. And I attached a couple of photos that were not in my book, but were closer to the sketch they had showed me at the casting (including the image on page 51).

In fact, I gave her three copies of each photo with the hope that she would pass the other two on to the art director and the editor.

However, I never bugged them on the telephone. I never begged. I just sent one professional and friendly letter that required no reply. It was my one last shot.

Two weeks passed, and I never heard back from the magazine. I was sure I didn't get it, when I heard I was being called back along with 4 or 5 other men. Again I posed in a Speedo and struck the pose. I demonstrated some of my techniques for showcasing my muscles, which helped differentiate me from the other excellent models.

I was ecstatic when I got word that I had been chosen. We shot the image in August— and finally nine months later it appeared in May, 2002.

"a parts model can't be afraid to get naked, figuratively and literally,"

todd riegler, ford models

the photo shoot

Unfortunately, the shoot was scheduled right around the time I was taking the Bar Exam. I knew I couldn't be a body model forever, so I really wanted to become a licensed lawyer. Yet this was the most important job in my modeling career.

This is where a lifetime of staying in great physical shape saved me. While I wanted to spend as much time as possible honing my body for the shoot, I was pretty close to my peak already, and was thus able to balance the studying for the Bar with preparation for the photograph.

My goal was to bring something extra to the shoot. I knew most photo shoots start with the creative concept, but often branch off from there. So I wanted to know the classic poses, as well as how to make the body look interesting.

I went to bookstores and libraries and looked at every highly posed nude male photo or painting (modern and classic) that I could find. I made stick figures of the poses, and then went to the gym and practiced them over and over.

I felt a little bit like a freak in the gym, standing in front of the mirror in a Speedo doing all these contortions. But I couldn't allow a little embarrassment to effect my preparation for the job of my dreams. It was my responsibility to be prepared, after all.

All this preparation allowed me to help the photographer. He'd take the one pose and then pause, and I'd say, "What about this?" and go into one of my stick figure poses. This allowed the shoot to go quickly and smoothly, with a lot of creative variations. It was a good example of how doing the preparation makes the actual shoot go faster.

Interestingly, it was supposed to be a nude shoot. But the *GQ* staff was very concerned about me being self-conscious, so they brought along a g-string, which was later retouched out. The funny part was that I had no qualms with posing nude, but it made the other people on set uncomfortable, so I wore it.

inside editorial

I was also offered the job of posing for the inside editorial article that accompanied the cover, entitled "*The Male Species.*" The shoot required having the human vascular, skeletal, and internal organs painted on my body with temporary tattoo paint.

The entire front of my body was painted, including a flesh colored g-string. The toughest part of this job was that it required ten hours of makeup application, much of it with an airbrush. This meant standing still, nearly naked, for the duration.

This is where your attitude and professionalism comes into play. The makeup artist and client had drastically miscalculated the amount of time the painting would take. I also had to scrub down with alcohol, because I was not forewarned that skin moisturizers and temporary tattoo paint don't mix!

Throughout the entire shoot I never complained or asked for a higher fee, and I remained jovial and professional throughout. After all, it also behooved me to make this photo the best it could be.

plus sizes, parts & other specialties

"I doubt there are ten models in new york city who make a living as a hand model." top industry insider

there are several specialties that are small but sometimes lucrative markets. They include Plus Size, Parts, and Pregnant models. Though a few agencies may have a division for these specialties, and occasionally a specialized "boutique" agency may go into business, they are a relatively small portion of the modeling business. Unfortunately, they are a large portion of modeling scams aimed at aspiring models. (See pages 106-111.)

plus sizes

If you are a woman who is Size 12 with an extremely well-proportioned body and the standard 5'9" to 5'11" height, you may want to consider Plus Size modeling. Keep in mind, it is a specialty market, primarily limited to catalog work. Often, this specialty is populated by former Teen and Women's Division models whose metabolisms have changed so that now they are a more natural Size 12.

parts modeling

There are people who make a living as a hand model or a foot model, but it is rare that they specialize in just that narrow market. The vast majority of "parts" models are people who are already signed on as models in an agency's other divisions. They just happen to have great hands, perfect feet, or amazing hair.

Con artists have honed in on this specialty, often telling aspiring models who don't meet the height or size requirements, or don't have the facial beauty required: "Don't worry, you can still have a wonderful career as a parts model." Time and time again, our insider sources shot down that theory.

An agent from a large model management company rhetorically asked us: "Why would an agent take on a person who can only model hands, when there are plenty of all-around models who have beautiful hands?"

Perhaps the most skilled portion of parts modeling is in the television category. This is because it takes great skill to do the required motion (such as reach out and pick up a product), over and over again, always hitting the exact mark and always looking smooth and graceful.

pregnant

Although there have been boutique agencies that specialize in pregnant models, most clients go to a larger agency when the need arises. Simple mathematical probability suggests that an agency with 200 or 300 models in their Women's Division, and still more in Commercial Print, are bound to have more than a few who are currently pregnant.

3
more than a pretty face

it takes more than just beauty to be a successful model

height & size

Some aspiring models are surprised to hear that the major agencies have very strict height and size requirements. Talent scouts often hear models complain that it "just isn't fair." However, fairness has nothing to do with these rules. It has to do with pure business reasons, five of which are:

1 Sample clothing from the designers are made long before a model is booked for a runway show, major fashion shoot, or advertisement. By knowing that all the models will be basically the same size, the designer only needs to make one sample dress. "It would be crazy for them to have to runaround and find a model that could fit their sample," said an industry insider. "They need to know that just about any model from the agency will fit the clothes."

2 In the major markets, the size requirements are fairly strict. For women, it's a height of 5'9" to 5'11" and Size 0 to 6. For men, it is 5'11" to 6'2" and 40 to 42R or L. That's the height that most designers feel make their clothes hang best. And while the size may vary a bit from year to year, especially in women, you'll rarely see a height exception.

"But I've heard about very successful shorter models!" is a refrain often heard by scouts. And the answer is, yes, there are a few models who are shorter or taller than the norm. However, these men and women invariably have something extra that is so special that clients are willing to work around these obstacles to use them. Also, if they are shorter, they must be extremely well-proportioned so they look taller in the photographs.

"Agencies in New York are going to tell you that their height requirement is 5'9"to 5'11" for the Women's Division, but every agency that exists has girls that are slightly shorter," admits agent David Grilli.

3 Photographic shoots with multiple models make the height requirement even more important. In the incredibly rare event that a designer is willing to specially cut clothing for a short model, they would look odd when standing next to other taller models.

4 "But I'm only going to be a hand or hair model! I don't need to be that height." Again, this refrain won't work. On pages 54-55 we discuss how most of today's "parts" modeling jobs are done by "regular" models who happen to also have nice hands, feet, or hair.

5 All this being said, some of the fringe specialties and freelance modeling opportunities are not as strict on sizes. You probably won't be able to make a living with these specialties, but it can be an otherwise rewarding hobby.

The average American woman is not the size of the ideal female model. And it is not a plot by the fashion industry to create an "unrealistic and unhealthy image" of what is the ideal woman in the minds of our younger generation. It's fulfilling a fantasy, and fantasy sells. Fashion is a business and a lot of marketing

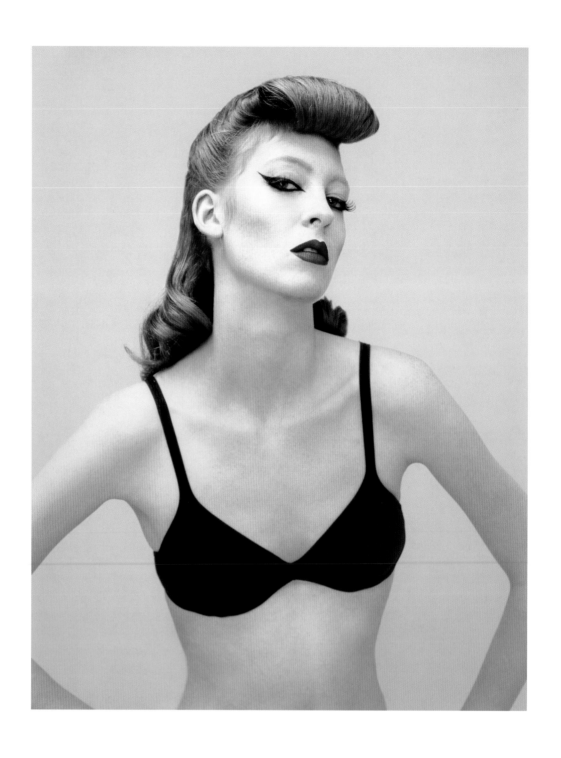

"petite model divisions don't exist in new york, and even in smaller cities the work is very minimal— so question any agent or scout who tells you otherwise."

eric bean, photographer

"exceptions to the height rules are rare. those who are even an inch short must have something so *special* that clients are willing to jump through hoops."

research is done to find out what image sells the product best.

The same is true of magazines. They get immediate feedback in terms of newsstand sales to figure out which cover image sells best. If it were the image of the Size 12 woman that sold better than the fantasy image, you can bet that every agency in every city would be full of Size 12 models.

"At Pauline's, we had Lonneke Engel who is really 5'5"to 5'6" and she had three million dollars in contracts— with Cover Girl, Ralph Lauren Fashion, and Ralph Lauren fragrance. So she was one of the most successful models in the business. But that is so rare, it becomes a statistical anomaly," adds David.

"The girls who are smaller have to realize that they need to encompass certain other qualities about themselves that will make people work around their height. Things like an *extremely* proportioned body so that on film they appear longer than they really are. And an *amazing* personality that makes people realize they are the exception to the rule," he adds.

"You can tweak the height and size measurements here and there," explains another source, "But for the most part you have to have been dealt certain cards to be able to make it as a model."

Modeling is not like some other careers where there are defined steps. If you study enough, get tutors, and make the grade, you're pretty much assured of getting a job as a postman, or a school teacher, or even a doctor. But in modeling, a lot of the criteria are out of your control.

Model Amie Hubertz gives a good example: "No amount of coaching and practicing is going to get an NBA contract for a really short guy. Nobody looks at that physical criteria as 'discrimination.' The modeling industry needs certain physical characteristics to be met as well."

breast size

Surprisingly, there is also a bra size requirement. Most agencies are looking for women with cup sizes *no larger* than B. Again, this is because of the size of the clothing. When needed, larger breasts can be faked, but you can't make them smaller on a whim. See page 71 for details on breast sizes.

male bodies

Similarly, for male models, you cannot have too muscled of a frame, especially in fashion. A suit simply doesn't look good when huge biceps are bulging against the seams.

The last decade of Abercrombie & Fitch catalogs go against this rule. Those muscled up models certainly achieved some fame for working that job. However, they may have trouble over the duration of their career getting more traditional fashion and editorial jobs if they're still that heavily muscled.

"Commercial print, sportswear catalogs, and body modeling allow more massive muscles than fashion, but we're still not talking about Mr. Universe," says body model Todd Riegler. If you come in and are too bulked up, your agent can help you scale down to a more marketable size."

fashions change

Just as fashions change, so do the height and size specifications of the "perfect model." Less than ten years ago, the ideal model was a size 6.

"During the most recent seasons, all my designers want Size 0 to Size 2 models," reported Mauricio Padilha. "The girls were still just as tall, but they were tiny. They had to fit in the sample clothes, and they had to look good."

health & diet

"modeling is all about healthy skin. excessive dieting, alcohol, or drug use will ruin it and you'll be out of work."

daniel lucas, personal trainer

Over and over, we heard from top industry insiders that successful models aren't anorexic or doing extreme diets to keep to the size requirements. It wasn't a conspiracy to keep a "terrible secret" hidden. It was a basic fact that any nutritionist or doctor will confirm: You simply can't starve yourself and still have beautiful skin and look beautiful in front of a camera. No amount of makeup can hide unhealthy living.

How prevalent is anorexia? David Grilli hasn't done a scientific study, but he reports: "I've been an agent almost 18 years, and in that time, I've had maybe 3 or 4 girls with an eating disorder out of hundreds of models that I've represented. And I think these girls had eating disorders before they were models, so I don't think it was triggered by the industry."

"Even if a client is looking for a girl who is incredibly small and thin, they're looking for a girl that is *naturally* that way," he adds. "When a model is not naturally skinny and makes herself skinnier through something

like anorexia or bulimia, it shows in other ways— it shows in her hair, it shows in her skin, it shows in her teeth. She just doesn't look healthy overall."

"A natural Size 8 is not going to diet down to a Size 2 and look good. Nor do you want a natural Size 2 to quickly gain weight to become a Size 8," confirms another inside source.

nutrition

Maturity can also change the equation. A girl who began modeling at 14 might have had the metabolism to remain Size 4 while eating pizza and fast-foods. But as she matures into a woman, her hormones change and her body might naturally move to much larger sizes.

This girl (now a woman) would have four choices. She could sign up with a nutritionist and a personal trainer to try and plan a healthier lifestyle and realistic goals. She could move toward Plus Size modeling. She could drop out of modeling to pursue school or another career. Or she could fad diet, compromising her health, and eventually leading to a failed modeling career. A good agent would obviously try to help her avoid the latter.

right
Models are under the impartial scrutiny of the camera lens. They have to look healthy on the job, so all aspects of their life must emphasize health. In addition to sleep, nutrition, and exercise, they should be wary of the long-term health effects of smoking and excessive alcohol consumption.

teenage determination

David Grilli describes the determination and life changes that one teenage girl needed to succeed:

There is a 15-year-old model at Code, who looked great when she was booked in December. I didn't see her over the holidays and by February she had gone up two sizes. We didn't realize it until she was sent home from a major shoot because she couldn't fit in any of the clothes.

She hadn't done anything wrong *per se*— she was just a normal teenager, and at that age your weight goes up and down like a yoyo as your metabolism changes.

Instead of becoming discouraged, she went to her parents and said "I don't want to give this up." So together with her parents, she started working with a nutritionist and a physical trainer.

So here's this teenager learning how to eat, and saying "No" to chocolate, French fries, pizza, soda pop. Then every day after school she gets on the treadmill and runs an hour. How many 14 or 15-year-olds are that dedicated?

A few months later the weight was down, her size was down, and most importantly she looked healthy. She had learned eating and exercise habits that will carry into her adult life. And she was ready and confident to work again.

And she did. Still just 15, she got a major hair campaign. They had a car pick her up at her hotel and take her to the shoot. It was all first class and everything a young girl dreams it will be. She made $30,000 in one day. But she earned it through months of hard work prior to that

If you don't have that kind of drive and determination, then this business is not for you.

"I could never be anorexic. I'd sooner leave the business and open a bakery next door to the wilhelmina agency."

amie hubertz, model

64

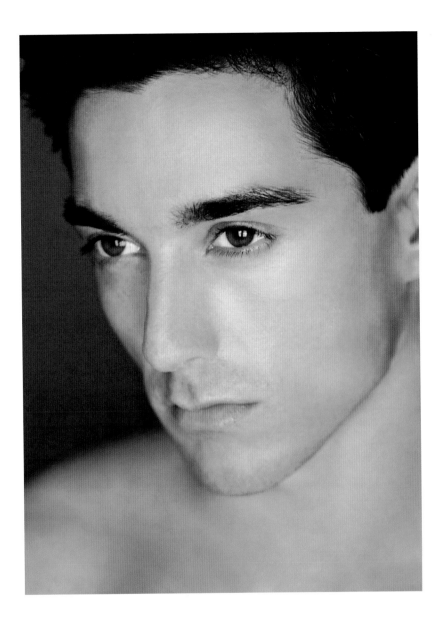

above
Skin care is important for both women *and* men. Models should avoid excessive exposure to the sun, as well as refrain from smoking.

Though most models are very careful about what they eat, the emphasis is on quality and health, not radical dieting. If your physique is such that you must take drastic measures to fit into the size criteria of your modeling specialties, your skin, hair and nails will suffer. Without that healthy glow, you simply won't get work.

All the models we spoke to had ways of tricking themselves into eating healthy. Amie Hubertz believes that "Moderation on a daily basis is ideal."

Body model Todd Riegler has a different strategy. He stays *very* disciplined eating healthy all the time, focusing on steamed vegetables and lean meats. Then, on an appointed "day off" he allows himself to eats whatever he wants. "Literally, that means a trip to Krispy Kreme Donuts or a plate of nachos," he reveals.

The best spent money for a model is on a gym membership, or consultations with a nutritionist. Living a healthy lifestyle is the only way to look your best.

day-to-day health
Carmen Dell'Orifice, who has been modeling for almost 60 years, professes that "Even though I'm lean by nature, I have to make the decision not to let my body go to pot." Health is more than just your weight, it's the quality of the food and the fitness of your body.

At 72 she still exercises regularly. "At my age, it's mostly stretching, because that is what I feel my body needs," she explains. "When I was a child, I was trained at classical Russian ballet, and today I still do an hour of isometrics and stretching on the ballet bar."

"When the public sees you during that runway walk, of course modeling looks like

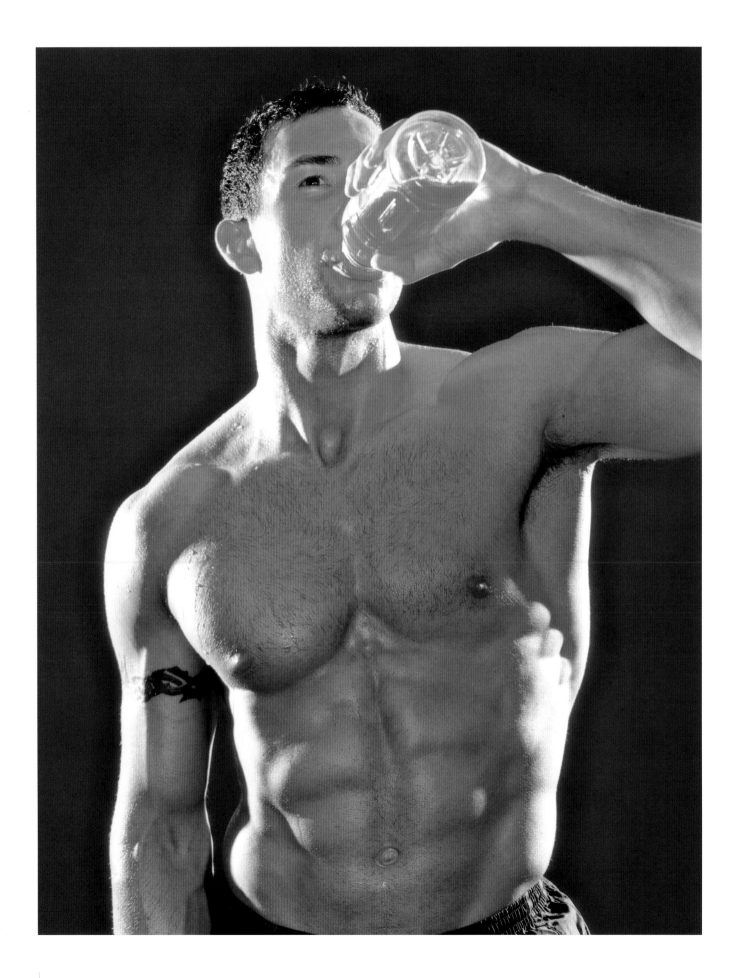

"late nights, colds, sunburn, bruises, allergic rashes, sport injuries, hangovers—these are things you don't have to worry about in other careers, but they'll put you out of a job as a model."

jodi kelly, model

pure glamour. But what they don't see are the hundreds of crunches you do, the early to bed schedule, the ice cream you had to forego, and cream under eyes every five minutes!" agrees model Jodi Kelly.

Carmen concurs, and points out a mistake many young, aspiring models make: "A lot of girls want to make money. They want the glamour of being a model. They don't think of it as being an athlete and training. It is hard work physically. It's fun, but it's exhausting. And you have to have your sleep."

"Being required to look good kind of forces you to look at yourself and be the best you can be. It's quite liberating, if you look at it that way!" says Amie Hubertz.

smoking

Some models start smoking cigarettes in a misguided effort to keep their weight down. This quickly backfires as their overall heath suffers, and they become addicted.

Carmen has seen smoking go in and out of vogue for the past six decades.

"Unfortunately, many aspiring models start smoking because they think it will help keep them thin, but it's really just an excuse for not putting in a true effort to stay thin by keeping in shape. Instead the smoke ruins their skin and harms their health."

She stresses, "When you're in your teens and 20s you might think your body is invincible. But this is when smoking and excessive drinking are the worst for you, because your body is not yet fully formed. Plus you get into the habit. If you feel you're addicted, go to a doctor now, before it's too late."

the drug myth

Not only is drug use illegal, it's bad for your health, and extremely unprofessional. You may be able to hide your habit for a while, or mistakenly believe it "helps" you stay slim and beautiful, but it catches up quickly.

"In the late 1970s, drug use was not uncommon behavior. In the 1980s a blind eye was turned to drugs in some circles. But we've gotten smarter as a society and it is

not acceptable in any way, shape, or form," says Darryl Brantley. "I only heard of two or three models using cocaine in my era, and they were probably doing drugs of some sort before they were models."

"If you walk into any big corporation, like Xerox, there will be people who are alcoholics or who use drugs and have a problem with it," explains David Grilli. "If you walk into McDonalds there will also be people who are alcoholics or who use drugs and have a problem with it. But they don't have cameras, reporters, and fashion magazines hanging over them and following them around looking for a story to sell. Models do, so you hear about it more," adds David.

"The working model gets up in the morning and is on set by 7 or 8 o'clock, works all day, leaves the set, goes to the gym for a few hours, goes home, goes to bed, gets up the next day, gets on a flight to Paris, gets off and goes directly to a booking, works three days, gets on a flight back to New York—- I can't imagine that someone could have a drug or alcohol abuse problem, do all that, and *still* look good!" explains David.

"That's not to say that there aren't models in the industry who have a drug problem," warns David. "Out of 55 models on my board, I only had one with a drug problem, and I'm pretty sure she had it before she came to New York."

"The second we realized it, we sent her home and are working with her parents to get her help. Hopefully, one day, she'll be healthy enough physically and mentally to come back to work. Until then, she's out of the industry."

below
Models must look healthy, and there is no way a model's hair, skin and nails can look this beautiful if she abuses drugs or alcohol.

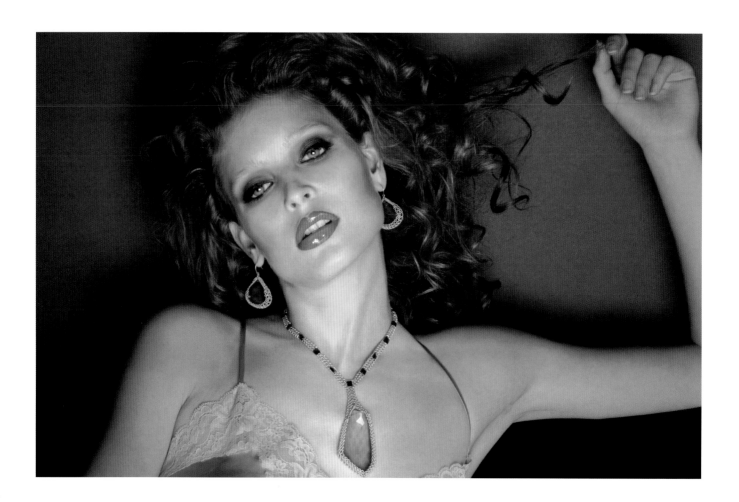

"you won't find any more alcohol & drug use in college-aged models than you'd find on any campus— and probably even less, because they are so health conscious."

david grilli, agent

tips from a trainer

Personal Trainer and certified Optimum Performance Coach, Daniel Lucas, frequently helps models reach their full potential. He offers this advice:

1. Verbalize your actual fitness goals. Ask professional trainers if they think your goals are realistic. For example, do you already have a great physique, and are just looking to tone up? Or are you trying to lose weight and get in shape?

2. Take a balanced approach to your fitness by combining healthy decisions about diet, exercise, and lifestyle.

3. Plan on working out three to four times a week. 90 minutes is ideal, including a warm up and an essential stretching period.

4. Most models want a full body program, designed for overall toning, but not bulking up. Core muscle work will help your posture and body alignment.

5. Dehydration affects your skin, your sleep, and your weight. Drink 64 ounces of water a day. You may want to increase that to 96 ounces if you are bigger or exercise heavily.

6. It is a myth that drinking too much water will cause you to "gain weight." Some bloating can occur if your sodium intake is high or you drink excessive amounts of water. However, proper hydration is essential to weight loss.

7. Listen to your body. You need to know, *really know*, when you feel healthy so you can repeat it through the same combination of diet and exercise.

8. And his final advice? Get off those machines and work free weights and aerobics. Get your body moving!

Daniel can be reached at dlucasnyc@yahoo.com.

breast augmentation

You might look at a Victoria's Secret catalog and think, "I need a large cup size to succeed." Not so. Most of those models are a B-cup at most.

The vast majority of successful models are no larger than a B-cup. Beautiful women with large breasts, especially those who are under the 5'9" minimum height tend to find success only in the hobby markets of swimsuit and nude modeling.

There are countless tricks a photographer can do to make a model's breasts look bigger. It is not uncommon for photographers to use padded bras, prostheses like inserts, push-up bras, or even tape to create the illusion of more cleavage. But you can't make them smaller if you have to fit into a sample dress cut for an A- or B-cup.

One insider warns: "Don't look at Tyra Banks and think you need augmentation. She has larger natural breasts, and it is a very rare exception in the fashion world. It usually works against you in fashion work, and is an even bigger negative in commercial print."

"Most lingerie clients specify they want a natural bust line," reveals David Grilli. "Some go as far as to say they will *not* book a girl if she has breast implants."

"We would never encourage a girl to have breast implants," he adds. "If they decide they want to anyway, it's a minimal enlargement. And it's rare."

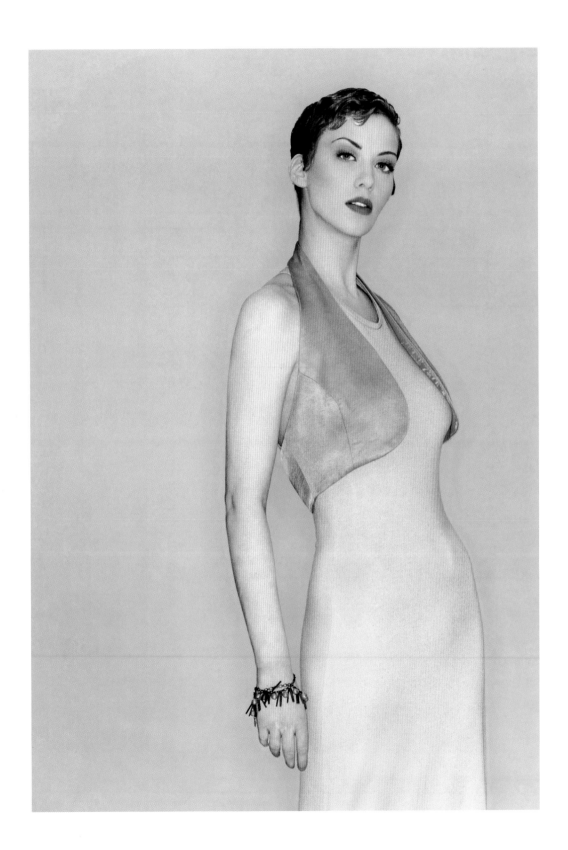

sleeping beauty

"if I have to leave the party early, someone invariably says, '*well I have to be at work early too, but I'm staying*'. true, but they can crawl into the office with a hangover, while my job requires that I look rested and beautiful at 6:00am."

<div align="right">jodi kelly, model</div>

t he importance of a good night's sleep cannot be overemphasized. If you want to be a model because it sounds like a round-the-clock MTV party, you're in for a big disappointment. A good night's sleep is paramount to looking your best. And there is not a soul alive who can look beautiful with a hangover. You won't be selected at castings or get repeat jobs if the photographer and makeup artist have to work overtime to correct for bags under your eyes or flaccid skin.

"Most people with 'normal' jobs can go to work a little rough and hung over, and still keep their jobs," explains David Grilli. "But a model has to walk on set at 6am the next morning and look like she got a great night's sleep. It's just not something you can fake."

left
Flawless skin comes from 24-hour a day care for your body. Even the best makeup job cannot hide poor skin. Clients will simply pick another model, rather than have to pay for expensive retouching to correct skin problems.

above
Male models usually wear minimal or no makeup during a photo shoot, so their skin must be flawless. And while wrinkles are an accepted sign of maturity, incredibly healthy and glowing skin is essential.

personality

"the prima donna 'diva' model is a media myth—with so many beautiful faces to choose from, why would I ever hire someone nasty?"

eric bean, photographer

personality might be your most important business skill in the modeling industry. Over and over again, we heard from our industry contacts that a positive outlook and pleasant personality was extremely important. As one fashion editor succinctly pointed out, "There are hundreds if not thousands of pretty models to pick from, so why would you choose someone who was difficult or unpleasant to work alongside?"

Cindy Crawford is famous for having a wonderful personality. So were other "supremodels" including Christie Brinkley, Bridget Hall, Kathy Ireland, Elle McPherson, Stephanie Seymour, Christie Turlington. "They were the consummate professionals," reflects a top agent.

"There are girls that are beautiful 10 times over," explains David Grilli, "but they don't have the type of personality that allows them to walk into the client's office and sell themselves in person. And that's just as important to their success."

Not only is a positive personality good for business, but it carries over into the photograph as well. "People's personality really does come out in the picture," agrees model Jodi Kelly.

Model Amie Hubertz points out that "personality" is subjective too. "The client and the photographer want to spend the day working with someone with a good personality, but that's subjective in its own right. Yes, you have to be polite and mannered, but beyond that, we're all people, and it's hit or miss whether you click or not."

attitude & outlook

It's also a matter of attitude and outlook. According to Jodi, "There can be discord on the set, art directors and photographers fighting, and everything going wrong, but my job is still to smile for the camera—

right
Your personality shines through the photograph— and that's part of what makes one person more or less "photogenic."

"you only hear the bad stuff in the press.
 which makes a better headline after all?
 'this model was nice on set' ... or 'that
 one was a bitch'? " top industry insider

"I always tell my models that it's the personality in the look that sells."

david grilli, agent

and it has to be 100% believable! Nobody will remember the problems on set, but they sure will remember if I don't exude happiness in the picture!"

"More than anything else, you can tell if a model is going to make it by how she presents herself in person, from physical looks to personality," adds David. "It's a sense of her energy."

Mauricio Padilha, who casts for over 30 runway shows a year, was happy to point out one of his pet peeves: "Some models actually hate what they do and they're just there for the money. They may be charming when they're on camera or working the runway, but I have to work with them backstage too."

"I was once paying a model $10,000 an hour (that's $8000 after they pay their commission to their agency), and I booked her for two hours," he recalls. "We were backstage and she was smoking with two of her friends. All the models were dressed

up and ready to go, and I said, 'Can you please go and get into your first outfit?' because we were starting the show in a few moments. And she looked at me and didn't say anything but just blew smoke in my face. I would never use her again."

Do the math on a $10,000/hour rate. That kind of paycheck means you're earning over $2 a *second*. This can give some models a big ego and make them think they're above it all. But when you're being paid that kind of money the pressure should be twice as much. That's the time to work doubly hard and make sure you're worth every penny of that fee.

Darryl Brantley, a former associate fashion editor and model booker with *Mirabella* magazine calls this the Babysitter Syndrome: "The babysitter is really nice to the parents, and then when they leave they're *nasty* to the kids. But they forget

that a lot of different people can influence future decisions about hiring them."

small community

Word gets around. "There were some girls where I was taken aback because they were rude at the casting or the shoot," says Darryl. "I'd call back the agent and ask 'Who is the bitchy girl you sent over here?' "

When word gets back to the agent, those models are the ones who don't get renewed. "I can't afford to have a long-time client stop using our agency because they start thinking the girls we send over have attitudes," adds David.

"This is definitley a business where you don't burn bridges," adds Amie Hubertz. "It's a very small world (especially in New York City), and it's the domino effect. The

photographers, the art directors, the clients, the agents, the stylists— they all know each other. And they all trade the industry gossip."

"Some of these models are still children," says Darryl. "They're teenagers who don't understand it's a job. But if they're teenagers who want to be in the modeling industry, they need to learn quickly to be successful."

"They're looking for glamour all the time," reports Jodi about young models. "But the moments of glamour are just that— *moments*. The rest is really hard work."

Model Carmen Dell'Orifice sums up what constitutes a good modeling attitude: "You better be labeled as somebody who at least tries their best, who is willing with a good disposition, and who is *not* looking at their watch to leave."

"there might have been five or six girls technically prettier than you at the casting, but who cares— you're fun, you're nice, and I like to be around you, so you win the job."

eric bean, photographer

you should *not* be a model if:

1. You can't handle rejection.

2. You aren't a naturally energetic personality.

3. You're looking to earn quick money

12 traits of successful models:

1. The camera loves your face.

2. You meet the basic size and height requirements of the industry.

3. You have an upbeat, friendly personality. You can be pleasant and sociable even on bad days.

4. You have good manners and professionalism. You are punctual and prepared for your appointments.

5. You are willing to work long, hard hours.

6. You are committed to your health and fitness, even at the expense of your social life.

7. You are willing to work on a 10-year plan, not just tomorrow's schedule.

8. You understand that modeling is a job, and part of a larger business of which you are just a small part.

9. You enjoy working with people of varied cultures and lifestyles.

10. You have incredible patience, both about the job at hand and your career in general.

elusive factors

n addition to the more obvious criteria needed to become a model (height, size, beauty, and health), there are some more elusive, less tangible factors that go into the equation. These are far more subjective, and one agency's opinion might be vastly different from another. Once you become a professional model going out on casting calls, you'll find the same is true of potential clients.

photogenic

Anyone who has ever taken a snapshot knows that some people photograph well, and others don't— and sometimes it doesn't correspond to how they look in "real life." How the camera "sees" you determines how photogenic you are.

"Success as a model has everything to do with how you photograph," emphasizes Michael Lange, Micon Worldwide. "It's not how you look in person."

"If you've really got it, it shows in a snapshot," explains model Carmen about what makes one person more photogenic than another. "Your mother can get a flattering photo of you with the cheapest camera. You can even put a dollar in one of those photo booths and get a strip of great pictures."

chameleon factor

"When I first started my career in modeling, my agent said, 'You look great and you'll do well, but you'll never be a supermodel,' " recalls model Jodi Kelly. "He said it was because I was a chameleon and I looked different in every picture."

"To become a supermodel in the 1990s," she adds, "someone had to be able to look at photos and say 'That's Cindy Crawford, that's her again, that's her again.' "

The good news for Jodi is that people who are more chameleon-like usually have longer careers. This is a fact she has proved, having been a professional model for over a decade.

patience

One of the more important traits or abilities of a model is patience. It sounds obvious and simple, but it isn't that straightforward.

"Some models don't have a lot of patience, because they shoot everyday and are overworked and jaded," comments makeup artist Cyrus. "For some of them, the fun is no longer in it. They change into these robots just working long hours, and that's no good for them personally, or for the photographs taken of them."

"You don't have patience? Then don't be a model," emphasizes Sam, a booker at Ford Models. "You won't survive. You won't last. It will never happen. You *have* to have patience in this business."

"I think people forget in this day and age that not everything is instant, especially the younger generation," he adds. "You may see every potential client in the entire city and never get a booking for six months..., and then boom, you get it. It's all about patience."

Carmen agrees, "It's about *finally* being in the right place at the right time— *finally* after a million times in the wrong place at the wrong time!"

Cyrus also points out that once you're on the job, there is still a lot of waiting around. "Hair and makeup alone usually takes 3 to 4 hours for commercial and fashion shoots. Once you are all dressed up and transformed into the character you will be on set, it's very glamorous at that point, but trust me— getting there isn't!"

the avon story

Model Jodi Kelly worked on a photo shoot that illustrates some of the more elusive qualities a good model may possess.

The assignment was to photograph winter clothing on location for an Avon catalog. Unfortunately, these catalogs are shot six months ahead of time, and it was now July in New York City, smack in the middle of a brutal heat wave.

Knowing the conditions were going to be bad, the photographer chose his model using three criteria:

1. She needs to have the appropriate look for Avon, with a wonderful, happy smile.

2. She doesn't complain and has a great attitude

3. She doesn't sweat as much as most people. "Jodi is freakishly dry!" jokes Eric. "But that really was a trait that helped get her the job."

The crew was able to locate a Christmas tree farm in New Jersey for the shoot, and the photographer, model, makeup artist, and stylist all trekked out there in a rented RV.

Fake snow was sprinkled on the trees. A big piece of diffusion material over the model turned direct sunlight into an overcast look. And Jodi was dressed in an overcoat, hat, mittens, and scarf in temperatures over 90 degrees.

The photo crew were all sweating like crazy, and having to take frequent water breaks, but not Jodi. She was a trooper the whole time, and never once complained about the situation.

"I had nothing to complain about," says Jodi, concerning the harsh conditions. "I've wanted to be a model my whole life. And here I am, on a job, getting paid for living my dream! I considered myself lucky despite the weather."

"she looked *expensive* when she came in. she looked happy, healthy, gorgeous, and had a great attitude. she couldn't give a rat's ass if I was going to book her or not. so I booked her on the spot."

mauricio padilha, Mao PR

grace

"Grace of movement comes from within," explains an inside source. "It is something you're either born with or you're not. You can hone it, and make yourself as graceful as possible through ballet, sports, and other schooling. But you either have it or you don't, and that shows in the photos."

uninhibited

You can't be too modest about your body in this industry. "You have to be really comfortable with your body," says model Jodi Kelly. "At a runway show you're just dressing and undressing as fast as you can and there is no time to cover up."

"And in a fashion magazine shoot," she adds, "they're going to be pinning you and touching you, putting makeup on your face, neck, and body. They pull, yank, and tease your hair. Nobody is intruding or crossing lines, but it needs to be done, and done very quickly."

confidence

Confidence and a feeling of well-being is an elusive quality that is paramount to a model. If you feel heavy, or shy, or clumsy, or if you are just worried about a pimple, that insecurity will show in the photograph.

open-mindedness

You need to have an open mind about the different types of people you will be working with in the modeling world. You have to be able to work with every type of person from every walk of life.

"This business is not a bubble," explains one insider source. "You will meet people of

above
Model Jodi Kelly needed a very positive attitude to dress up in winter clothes in 90-degree weather. Read more about this catalog shot on the previous page.

every culture, religion, every race, and sexual orientation. And you have to be able to work with everybody."

the big picture

And finally, you'll need an understanding of the "bigger picture" that only experience can bring. This is hard for a young model who is swept up with the glamour and excitement, and who has seen too many bad movies or read too many tabloid articles.

"They are lead to believe they're the center of the universe, when they're really just one part of a creative process that involves art directors, photographers, stylists, makeup artists, and other personnel," explains David.

What the model might not realize is that the creative plan could have been in the works for weeks, and all sorts of people have approved every step. And the decisions were made by people with a lot more experience than him or her.

"It's sad when I see a model trying to change her makeup, hair, or wardrobe because she thinks she knows how she looks best," says makeup artist Cyrus.

Jodi Kelly concurs: "If you don't trust the creative staff, or start trying to tell the client who hired you what is best, you won't just make them mad, you'll miss out on all the creativity out there. You'll end up with a book full of one-dimensional, boring photographs of yourself."

"Really remember that you are just one part of a whole big picture," she adds. "You need to be aware of what the other people around you are doing because there are definitely different poses and facial expressions for different types of makeup, clothing, and lighting. So you need to be aware of the total creative intent so you can deliver what they need."

"if you think you *know* how you look best and don't trust the vision of the photographer or the makeup artist, you'll lose out on all the creativity that's out there. all your pictures will be one-dimensional." jodi kelly, model

other skills

there are a number of classes that an aspiring model could take to learn skills that might help them in their future career. We polled over a dozen agents, bookers, scouts, casting directors, and models and asked them to name their favorites. Some of their answers were predictable, and some were surprising. But all of them make sense for an aspiring model.

Karaoke was a surprising answer until one source explained. "If you can make a fool of yourself in front of a restaurant or bar full of people, chances are you can be confident enough to take a great photo."

"In modeling, you can't be inhibited," they added. "You have to be able to be loose and roll with the punches. You have to have a personality in front of the camera."

but not build bulky muscle. Dancing never hurts, because being able to move gracefully is always good."

dance & performance

Probably the most often recommended class was dance. This was because it combined two major benefits— fitness and awareness of your body.

Singing or any other performance art is also good— especially if you have no natural talent in it. Performing will really help you get over any inhibitions that would affect your comfort in front of the camera.

Sam, a booker at Ford Models suggested taking an acting class, even if you never plan on branching out into film, television, or theater. "As a model, you're basically pretending to be someone else when you're on set," he explains.

yoga classes

Yoga is another class that helps teach body awareness. Model Carmen Dell'Orifice suggests yoga instead of some of the faster more aerobic workouts. "The sensuality of the slow control of yoga is useful in modeling. Yoga teaches you how to breath, and how to focus on your body position, and how to focus on what is around you."

other fitness

Regardless of what type of exercise you choose, you need some sort of dedicated regime. "If someone is interested in becoming a model, they should be in great shape. No excuses," states Katie Ford, Ford Models. "They should exercise,

business classes

Business oriented classes were also suggested. Classes on interviewing techniques, public speaking (such as Toastmasters Clubs), effective presentation, and sales techniques can all yield useful skills.

your mirror

Working at home in front of the mirror is important too. "When starting out, I looked at a lot of magazines to see what looked good. Then I played in front of the mirror to try and copy these poses and see how they looked on me," says model Jodi Kelly.

Body model Todd Riegler describes on page 52-53 the intense research and posing practice he did before his first big cover shoot for *GQ* magazine.

above
There are dozens of
different types of smiles,
and a good model can
deliver them on cue so it
looks believable on film.

the smile

Smiling on cue is also something of an "art form." There are so many different smiles. Coy smile? Big teethy happy smile? The best training is to practice in front of the mirror, or in front of a friend who will give you honest opinions without laughing too much.

Jodi explains: "It's not as easy as you think. You're in a very unnatural setting. You're up there in front of the lights. The makeup person is scrutinizing you to make sure your eyelashes are still perfect. The stylist is checking that the clothing is draping well. And when they say 'smile,' it's not the most natural feeling to look really happy and comfortable. But that's the job."

"You also have to learn how to show the clothes or the product," adds Jodi.

"Whether it's high fashion, runway work, or a commercial print job, you have to show the product in a way that is *appropriate* for the situation."

self-improvement

Carmen broadens this category considerably, explaining that anything you do on the outside world to improve yourself will bring something new to each and every photograph. "Even intellectual pursuits. Study French!"

Carmen's final advice? "You can't live in one dimension. You must live on all dimensions at all times. Don't be lazy. And don't be afraid."

4

getting started in modeling

there are several different ways to be "discovered"

being discovered

"the first step toward becoming a model is to get noticed and taken in by a credible agency."

to begin working as a professional model is all about joining an agency that will represent you and help you get modeling jobs. Finding the right agency for your looks and talent is the entire game plan. (See freelance modeling on pages 22-25 if you only want to do it part-time.) How you go about attracting that agency is where the variations in your game plan will occur.

There are 3 basic paths to follow.

1 You are lucky enough to be scouted on the street by a credible talent scout or perhaps even a major advertiser. This method relies on luck— but not as much as you'd think.

"If you've been in New York City for a month, and nobody in the industry hasn't stopped you in the street, then you're not model material," brazenly states Michael Lange, Micon Worldwide.

Though perhaps extreme, there is a lot of truth to this statement. Agents, talent scouts, photographers, stylists, makeup artists, the clients who hire models, and every other person related to the modeling industry is always on the lookout for "new faces." If you live in a major fashion city such as New York, Los Angeles, or Chicago, chances are you're going to cross paths with one of them.

We've heard photographers lament that every time they approach a potential new model, they've already been scouted.

Michael Lange, casting director at Micon Worldwide, tells the story of seeing a young man in a bakery at 1:00am in the morning. "He was perfect for a Perry Ellis runway show we were planning. Just perfect."

Michael gave him his card and asked him to call about it. To Michael's disappointment, the man never called. Six months later, while planning a different fashion/runway show, a new model was brought to his attention. It turned out to be the same man.

"He admitted that he wasn't sure he wanted to get into modeling when Michael had first approached him. But soon after, he was approached by *another* agent and entered the business."

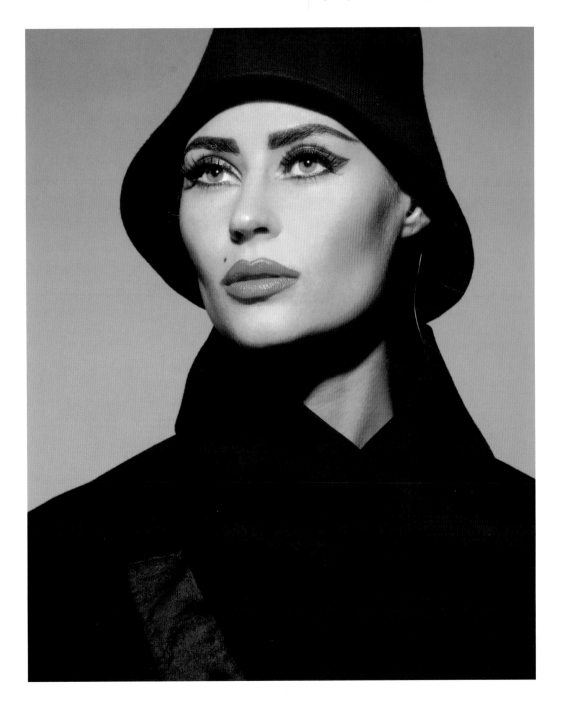

"if you've been in new york city a month
and nobody in the industry has
stopped you in the street, then you're
not model material." michael lange, micon worldwide

Lindsey Kraft, a popular Teen Division model, now with Code Management was originally "discovered" by soliciting agencies directly. She recalls:

I was 16-years-old and a total athlete. Modeling had never really occurred to me. My father sent in my "Sweet 16" picture to 11 different New York agencies without telling me. The first I knew about it was when he told me that *nine* of the agencies had responded.

So I took the day off from school and we went in and met with the agencies. I thought it was kind of a joke and my chances were zero, so I didn't even tell my friends what I was doing! But I ended up testing with IMG and then signing on with Wilhelmina.

Even so, it took a while to get started. The first photographer I went to for test shots didn't want me to smile at all. He wanted totally expressionless pictures.

It wasn't until I worked with a second photographer, John Getty, that it all came together. He made me laugh at one point, and then he exclaimed, "Don't stop laughing!"

above
Once you're established, your agent will help you design a "comp card," which you can send to or leave with potential clients.

So all the new pictures had my huge smile, which is now kind of my "signature." Suddenly with those photos in my book I started getting work.

Prior to modeling, I'd only done babysitting. It was just amazing to still be in high school and now have this kind of job!

left
A simple, clean head-and-shoulders snapshot and full or 3/4-body shot are all you need to send to an agency. Sometimes an agency will send out a new model with no more than a Polaroid print like these.

"it's a feather in your cap to have been the one to discover that shiny new penny— to be the person who reveals them to the new york fashion audience first." michael lange, micon worldwide

The moral of this story is of course, that talent will be scouted, over and over again, if you really do "have the look."

However, as an aspiring model, be *very wary* of those who "scout" you because this is also one of the common scenarios for a scam. Try to figure out their authenticity before jumping. Take their name and work number, and contact them, rather than the other way around. And carefully read the "avoiding scams" section on pages 106-111.

2 Local scouting, outside of New York City occurs as well. Many major agencies have satellite offices in other cities around the United States and abroad. Others have agreements that give smaller local agencies a commission if they "discover" a model that the larger agency wants to take on.

Local scouting also happens at modeling conventions (see pages 100-103), talent searches, and similar events. Here again, pay attention to scam and quasi-scam companies that are in the business of selling dreams rather than finding models. (See pages 106-111 for information on avoiding scams.)

3 Soliciting agencies directly is the third and most effective and reliable method. It's also one of the cheapest, because it avoids any middlemen.

Simply have a snapshot or two taken of yourself, following the guidelines on page 96-99. Have them processed at the one-hour lab. Select a face shot and a body shot. Write your name and address on the back of each print.

Then write a short cover letter introducing yourself and giving your specifications (age, height, weight and measurements). Create a SASE (self-addressed, stamped envelope) and enclose it with the letter and photos. Then send it to the agencies of your choice.

"We have someone who looks at pictures all day long," reports Katie Ford, President of Ford Models. "And we really do find models that way!"

approaching an agency

after reading this book, if you think modeling is "right" for you, there is a quick and inexpensive way to test the waters. Take the initiative and contact some of the top agencies yourself. Forget waiting to "be discovered." Forget the middleman of a scout, search contest, or convention.

It takes some initiative, but that's good because it will weed out the people who aren't as dedicated as you. You'll have to do some research and write some letters, and perhaps make a few phone calls. If you're not willing to do that, or never seem to get around to it, then modeling probably isn't the right career for you. Being a successful model is *a lot* more work than just smiling for the camera.

There are two basic ways to approach an agency cold (*i.e.*, without a personal invite): go to an "open call," or send in a photo submission by mail, email, or through their website. Not all agencies have open calls, and not all accept electronic submissions. However, *all* of them have a preferred method of contact, and that will be your first step in the research.

First gather a list of agencies you'd like to contact. Start your search at the library (or on the Internet). The goal is to differentiate the true working agencies from the quasi-scams. Don't be afraid to ask the refernce librarian for help finding business periodicals and directories! Other information can be found on the Internet at sites like www.onemodelplace.com and www.models.com.

Once you have a list of desirable agencies you can do an Internet search under that agency's name. Not all agencies have websites. In fact some of the bigger ones choose not to. But if they do, you can visit the site and see if they have a section for aspiring models, "becoming a model" or FAQs (frequently asked questions). The site may give you step by step instructions on how to make your submission.

If the agency does not have a website, or the information you need is not on it, you'll need to use the phone. Again, your local library will have reference books that will help you find the main office number. Call the switchboard and ask for information on "submitting photos for consideration" or on the dates and times of open calls.

Don't be surprised if they switch you to an automated message or ask you to send in an SASE (self-addressed, stamped envelope) for written guidelines. They're not being rude. They just get an astounding number of inquiries.

Follow the directions you get exactly. Send in your submission, and you're done. *Don't* expect an answer. Not all agencies send out rejection letters. But if you get a phone call asking you to come in for an interview you've made a huge leap.

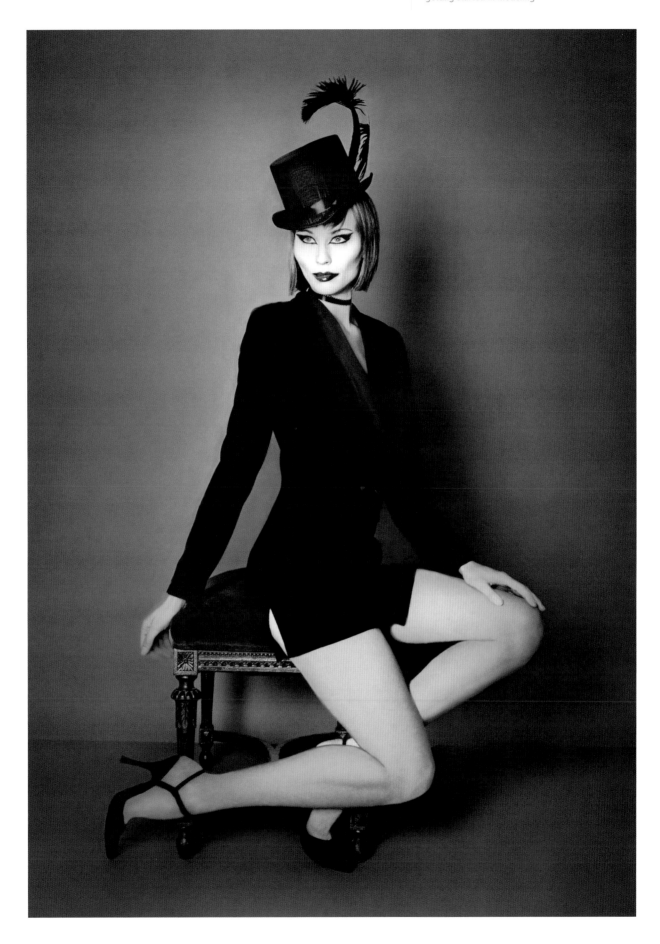

Don't assume the phone call means you've made it— it just means you've made it through the front door, which is actually a statistically impressive thing. Thousands of people didn't get a call back, but you did!

In Lindsey's Story (page 92), her father sent her "Sweet 16" photo to 11 agencies in New York City and got back an impressive nine responses. Even so, most of those agencies turned her down when she went in to see them. Either she was too short at the time, not what they were looking for right then and there, or there was some other subjective reason she will never know.

As exciting as your call-back may be, it is by no means a guarantee that the agency wants to take you on. It just means you've passed through the first hoop.

Even so, keep your feet on the ground. It is during the call-back process that you are interviewing the agency as much as they are interviewing you.

"This is also the time to have your 'scam-o-meter' on high," warns an inside industry source. "If they start asking for any money up front, walk out. You've mistaken this agency for a legitimate one!"

above
A simple outdoor snapshot is all you need.

first photos

It's hard to believe, but the agencies really do want simple, unposed snapshots. Why? It shows off how you really look, before the magic of makeup, lighting, and retouching. If the agency takes you on, they'll want to create a certain look for you, and that means sending you to a specific photographer. Most importantly, sending just a snapshot helps you avoid con artists who will try to make you spend a small fortune on a portfolio.

"If it is going to happen for you, it's going to happen no matter what photos you bring

the agency," says Mauricio Padilha of Mao Public Relations. "If they see what they're supposed to see in you, they're going to take you on immediately. They're not going to let you walk out the door so another agency can get you."

"When I worked at Pauline's," recalls David Grilli, now of Code Management, "We sent Alexandria S. out in her first week with just a Polaroid we had snapped in the office. She went to photographer Steven Meisel with nothing else in her book. Three weeks later he confirmed her for a shoot for the cover of *Italian Vogue*. "

"Right girl, right time, right personality, right place— it's a combination of several different elements coming together at once to make a job like that come to fruition."

legitimate photos

Even though you don't *need* fancy, professional "modeling" pictures to attract an agent, for some models it's a fun experience. If you have the money and want to see if you enjoy modeling, many local portrait studios offer "modeling portfolios" or "glamour packages." These sessions are not cheap, but you might like having the photos for personal use. With the photographer's permission, you can also use them to promote yourself if you decide to do freelance modeling (see pages 22-25).

However, if your goal is to get an agent and have a modeling career, these types of photos are not necessary. "All they tell me is that the person has enough spare cash that they can afford professional photos," says David. "All we need are snapshots."

"don't spend any money on a portfolio. just have your mother or a friend take snapshots and develop them at k-mart. no kidding. that's all we need."

sam, ford models

take your own photos

Share these six steps with your "photographer" and you'll be able to take the kind of snapshots most agencies are looking for. A point-and-shoot camera with a zoom lens or an SLR camera with a zoom lens are preferable.

1. CLOTHING: Wear simple clothing that shows off your form. For women, this could be shorts or form-fitting jeans and a tank top. Men should wear shorts or jeans, and no shirt.

2. HAIR & MAKEUP: Your face should be clean and without makeup. Your hair should be plain and unstyled. If it tends to fall over your face, pull it back so that your facial features can be seen.

3. LIGHTING: Stand outdoors in open shade for the best results. Avoid thin tree cover, which might put dappled light on your face. On-camera flash tends to flatten facial features, so turn it off.

If shooting outdoors select ISO 100 or 200 film for the best results. If you must shoot indoors, try and pose the subject in soft window light, and use ISO 800 film (with the flash off).

4. POSES: The agency will want to see one close head shot and one full-body (or 3/4-body) shot. Shoot the pictures with the camera sideways in the vertical format.

5. CAMERA CONTROLS: For the most flattering pictures, zoom the lens to the 70mm to 105mm setting. Then step back until the composition is right at this setting.

6. IDENTIFICATION: After your prints are processed, be sure to print your name and contact information on every image, in case the photo gets separated from your cover letter.

"spending all this money to get photographs of yourself *before* you're with an agency is total bull. if someone tells you otherwise, they're taking advantage of you."

mauricio padilha, mao public relations

right
This is a picture that an established model might use in their book. Nicole is shown here in full make-up and with styled hair.

previous page
However, the agency that is considering you as a potential model wants to see a clean-faced, unposed, simple snap-shot— such as the simpler shots of model Nicole taken when she arrived to the shoot.

conventions

"don't be insulted if I only give you ten seconds at a convention because I have 200 other people to see — just make sure it's your best ten seconds *ever*!"

david grilli, agent

Conventions are a legitimate way of being "discovered." The premise is sound. Agents and talent scouts can come from all over the United States, and in one or two days they can efficiently meet hundreds if not thousands of aspiring models. Likewise, the models can meet numerous different agents in one fell swoop.

Unfortunately, there are good conventions and bad conventions, and determining which is which is not so easy.

"We attend conventions if we feel that they are not trying to rip kids off," reports Sam, a booker and scout from Ford Models. "If they're telling 5'4" girls and 5'8" guys that they have a chance as a fashion model, then it becomes a waste of everybody's time."

Why? Because even though you may have a great face and a great body, if you don't fit the height and size requirements of the industry, you won't get much work. "Sure you might do one or two jobs," explains Sam, "but we're looking for someone who can work every day, for years. And that means they fit the height and size criteria."

If the convention host has salespeople (sometimes called "modeling scouts") out hustling up attendees without regard to their actual potential, then think twice about this convention. Some salespeople get commissions if they get you to sign up, and in this case, their motivation could become quantity, rather than what's in your best interest.

Also check *which* modeling agencies are attending and which divisions from those agencies, because some have different scouts for the different divisions. Look for top names like Ford, IMG, and Next. If you are a Male model, a Classic model, or the parent of an aspiring Child model, you should check and see if there are enough agencies that either specialize in your category or at least have a division in that specialty.

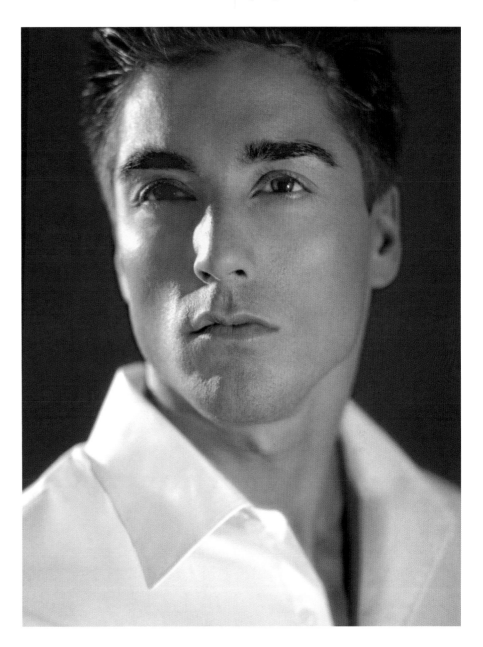

what to expect

Once you've chosen to attend a convention, you'll need to know what to expect. They vary greatly by company, but a typical one will include lectures on the modeling and acting industries. You'll probably fill out a questionnaire when you arrive, so give some thought to typical questions, like "Why do you want to be a model?"

The scouting portion of the day sometimes begins with a "performance" that is a runway show, which shares similarities with a beauty pageant. The convention company will tell you what type of clothing to wear if there is a performance.

Next, you get in line and move from one agent to another for a few seconds of discussions. They may ask you for a photo at this time, but it does *not* have to be from a professional photo shoot. (See pages 96-99 for information on shooting photographs for this purpose.) Make sure you bring several prints or color

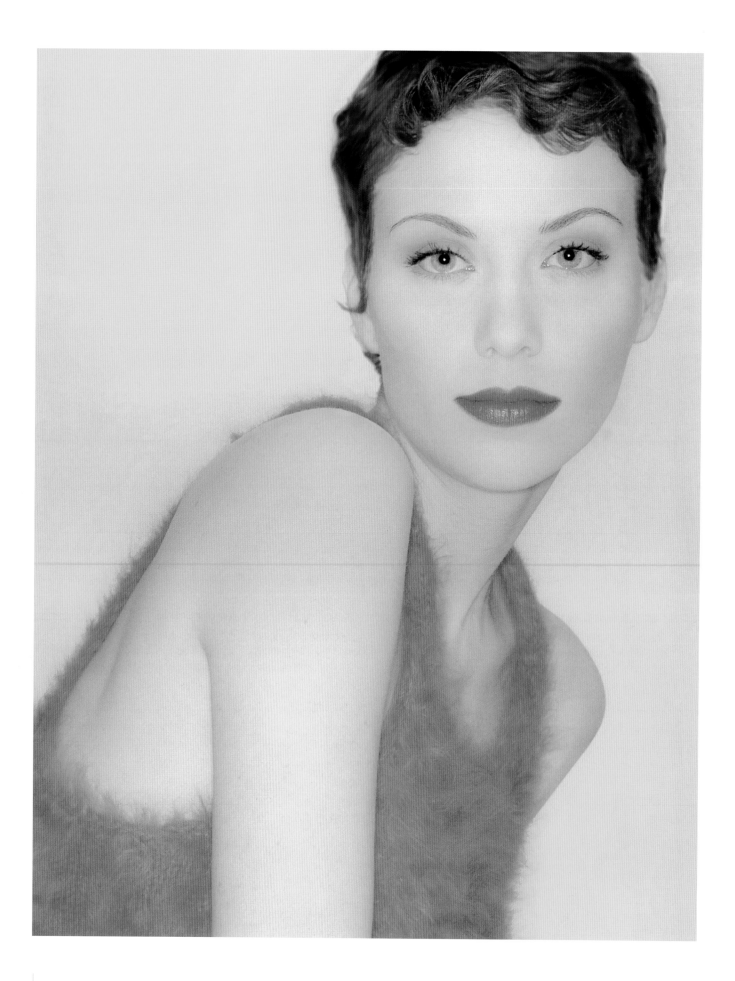

photocopies of the photo, and put your name and contact information on the back of each.

Don't spend a lot of money on photos for a portfolio. No one expects or wants you to have one at this point in your career.

If you are lucky enough to be what the agent is looking for, they'll ask for a call-back. Each convention has a system for listing call-backs, such as a large board on which lists are posted, so make sure you know what and where it is. It will list a time and a place to meet that agent for a second, one-on-one interview.

Remember that the agent visiting the convention is seeing hundreds of potential models in succession. He may only have a few seconds to talk with each person, so make sure you're ready to make the most of those few moments. Whatever you do, don't get flustered or annoyed with long lines or the short interviews. He or she will be looking for a person who can be upbeat and pleasant even in adverse conditions.

what they look for

"We're looking for someone to blow our socks off," explains David Grilli. "However, it is sometimes very subjective. I may go to an event and see 200 girls, but not one of them is right for me. Yet the scout next to me may find five from the same 200 girls."

"The runway portion of a convention is important to me," explains David. "I want to see how comfortable you are in front of a room full of strangers."

"At that point" he continues, "I'm not looking for a perfect walk. I'm looking more for a confidence factor. How comfortable are you in your own skin on the runway? If you can pull that off, and I like your look, I'll call you back for a 15 minute one-on-one interview, which gives me a pretty good idea about how you present yourself in person."

Michael Lange concurs. "I go to these conventions and I see these kids try to mimic what a runway walk should be, and it always ends up looking really silly and contrived. They're sashaying and swinging their hips and it just looks ridiculous on a 14-year-old."

"Instead, just be yourself. It's about feeling relaxed and not too stiff," adds Michael.

The interview portion is important, because it relates directly to a future aspect of a modeling career— the casting interview or audition. "If you can impress me as a person in a five minute convention interview, then you can probably make an impression on a perspective client at a casting call," explains David.

If you pass that stage, the next step is telephone correspondence for a few weeks.

If the aspiring model's personality continues to reveal itself in a positive manner, and others at the agency are excited by their picture, then an invitation is usually extended to them to come to New York, where they take it a little further.

which convention?

Don't confuse the cost of a convention with the quality. Some businesses put high price tags on their goods and services, just to play on people's psyche and hope they think it *must* therefore be better. Instead, pick the convention that offers the most of what you need— specific agents or perhaps useful lectures.

Next decide if the cost of the convention is worth the exposure. If it is local and you don't need to pay for travel and hotels, it may be a worthwhile idea. You may also decide, however, that it is more economical to fly to New York City or Chicago and spend a week visiting agencies directly.

Or simply decide if their list of attending agencies is any better than the list you could come up with through your own research. Then use the methods described on pages 96-99 to find out how to submit your photograph directly to them.

modeling schools

Schools that teach modeling are among the most hotly debated topics with aspiring models. It's not hard to imagine a teenager using this logic: "If I can go to college and become a school teacher or doctor, why can't you go to school and become a model?" Unfortunately, while good grades can virtually guarantee you a career in many other specialties, this formula does *not* work with modeling.

"A modeling school does not make you into a model," emphasizes Katie Ford, Ford Models. "It can teach you how to do makeup, or how to walk gracefully. But you have to born with the physical characteristics it takes to be a model."

While this concept might sound harsh to some, it's a reality of the business. Amie Hubertz, a successful model with Code Management, sums it up nicely with the analogy that it is no different than telling a short guy that no amount of coaching and practice is going to turn him into a professional basketball player in the NBA.

This being said, modeling schools are a benefit for some aspiring models. Model Jodi Kelly, who has taught modeling classes, adds that a modeling school is best for shy girls who need time to become more comfortable with their beauty.

"A good modeling school is really a finishing school in the classic sense," adds Jodi. "It can help you become more confident in front of groups of people and in front of the camera."

However, she strongly emphasizes that it is *not* a necessity. "Modeling school will not make or break a model either way," she says. "If you have the money and think it will be fun, great! Otherwise, your money may be better spent just traveling to a major city and visiting agencies."

Other industry insiders felt it was a complete waste of money. "Nobody can come in and teach a girl how to walk 'fierce' for the runway," insists Mauricio Padilha of Mao Public Relations, an agency that casts for many runway shows. "It's a combination of genetics, practice and confidence, and I hate to see girls waste their money on classes."

David Grilli of Code Management takes a hard stance as well: "If you came out of a modeling school and got picked up by a big agent, chances are you could have gotten that same agent by walking into their office without any schooling."

"We'll teach them everything they need to know," he adds. "That's part of a good agency's job."

Watch out for scam (or borderline scam) schools as well. Before enrolling, find out if the school lets in anyone who hands them a check regardless of their long-term chances of becoming a model. This type of operation may very well count on keeping girls "hooked" with unrealistic promises that they really do have what it takes.

"Professional scouts who recruit models claim that modeling schools make money by telling girls what they want to hear, but don't help them land a job or launch a career," explains Shirley Rooker, Federal Trade Commission.

"I get letters every day from girls who are only 5'6" that have been told they have a promising career as a Petit or Hair model," reports one inside source. "That's simply not true. They may get lucky with a $100 job here and there, but there probably isn't a career waiting for them because they don't meet the basic size requirements of the major markets. I hate to see modeling schools cajoling them along, all the while cashing their checks."

"a modeling school can be a fun and esteem-building experience, but it won't guarantee a career."

jodi kelly, model

right
A modeling school might help you become more comfortable in front of the camera, but it is not a necessity. Most of the agents we interviewed consider it a waste of money.

avoiding scams

t is an unfortunate reality that con artists are attracted to the modeling industry, but they have been targeting it for decades. Model Carmen Dell'Orifice even recalls the scams directed at young mothers from her early days as a model in the1940s. Many aspiring models (especially teens) and the parents of beautiful children become easy targets if they let their dreams, desires, and fantasies impair their judgment. They may want to become a model so badly, or be so appreciative of the gushing compliments given by "talent scouts" that they are willing to spend money to join a bogus or quasi-real agency, get expensive photographs taken, create comp cards, or enroll in "essential classes."

The confusing part is that some models really are "scouted" in everyday places by professional talent scouts. So when somebody says, "You could be a model," how do you determine if they are a legitimate scout, a con artist, or a sleazy character with an overused pickup line?

The best way is to take their business card, and contact them later, when the "high" of being so flattered has worn off. Don't give them your number— take theirs! Then go to the phone book and look up the company. Call the main switchboard (not the number on the card) and ask for the person. That will rule out sleazy imposters.

Next begin a systematic check of the company to determine if it is legitimate.

Check with the local Better Business Bureau (BBB), and follow the 20 tips on pages 109-110.

Remember that scams come in many different forms. One of the most common is the talent scout who "discovers" you and then charges you a lot of money up front.

Legitimate scouts and agencies *never* ask you for money up front. Once you're signed with an agency, there will be fees for comp cards, for test shootings, and for messenger service to send out your book. But these are *always* fronted by the agency, and then deducted from your future earnings. So if the agent never gets you a paid job, they take the loss, not you! This makes it in their best interest to get you as much work as possible.

The most legitimate scout is paid a percentage of the agent's percentage. For example if a legitimate agency gets 20% of a model's earnings for their services (see pages 131-133), then the scout that discovered the model might earn a percentage of the *agent's* portion. Therefore, they have the incentive to find quality models who really will be able to earn a lot of money in the business.

Since the legitimate scout (like the legitimate agent) makes no money if the model makes no money, it is a waste of their time to "scout" anyone whom they're not extremely sure about succeeding. The scout who gets a commission based on volume may just be in the business of selling dreams.

school scams

Other scams include modeling schools that are more interested in telling their students what they want to hear, than preparing them for a real career. (See page 104-105.) They also may require that you buy services from vendors with whom they are affiliated. Talk to former students to find out what they thought of the school *before* you enroll.

contests & searches

Watch out for Photo Contests and Model Searches where you "win" a contract with an agent, but have to use a particular photographer to take the picture. If it is a legitimate agency, you can just send in an ordinary snapshot to be considered— without having to pay for the services of this photographer (See page 96-97 on photo submission information.)

Also be wary of "star searches" that charge large admission or entry fees. Like conventions, before putting down your money, find out which agencies and casting directors will actually be screening you. (See pages 100-103 for details on conventions.)

internet agencies

The newest genre of scams are the Internet "agencies" that justify huge fees claiming that the top agencies and clients frequently browse their files to find "new faces." It could be true, but when researching this

"some modeling schools make money telling girls what they want to hear, and selling them services they don't need." top industry insider

book not one of the agents we interviewed had ever found a model this way, or *even tried* to do so.

However, we did hear from some freelance models that they picked up occasional small jobs through an Internet modeling site. These were mostly low pay or no pay, though one model did have her expenses paid (and hence a "free" vacation) for a location shoot in Miami. Therefore, weigh the cost of posting *versus* the potential for paid work before investing.

"Ego gratification is the only reason to pay to post your pictures on an Internet scouting site. Why spend the money there, when you can simply send a few pictures to a few agencies and *know* they've been looked at?" points out one of our modeling agency insiders. "Even if the site isn't a scam, it's still not good economics."

what they say
versus
what they mean

Even the Federal Trade Commission has a sense of humor! They published this fun, but still serious, scam translator for aspiring models.

what they say: We're scouting for people with your "look" to model and act.
translation: I need to sign up as many people as possible. My commission depends on it.

what they say: Your deposit is totally refundable.
translation: Your deposit is refundable only if you meet very strict refund conditions.

what they say: You must be specially selected for our program. Our talent experts will carefully evaluate your chances at success in the field and will only accept a few people into our program.
translation: We take almost everyone.

what they say: There's a guaranteed refund if you're not accepted into the program.
translation: Everyone's accepted into the program. Forget the refund.

what they say: You can't afford our fees? No problem. You can work them off with the high-paying jobs we'll get you.
translation: We demand payment, whether or not you get work.

what they say: Commissions from our clients are our major source of income.
translation: Our income comes from the fees we charge you.

Visit www.ftc.gov/bcp/conline/pubs/services/model.htm

"a high price tag on a convention or school doesn't necessarily mean a better product or service. it might just mean a higher price." common sense

advice from the feds

Disreputable individuals and companies that prey on the hopes of aspiring models have become so prevalent that the Federal Trade Commission (FTC) has come out with the following 13 guidelines to help you protect yourself:

1 Ask yourself, "*why me?*" Don't let your emotions— and the company's flattery— take control. Think carefully and critically about how you and others like you were approached.

2 Avoid high-pressure sales tactics. Never sign a document without reading and understanding it first. In fact, ask for a blank copy of the contract to take home and review with someone you trust. If the company refuses, walk away.

3 Be leery of companies that only accept cash or money orders. Read it as a *strong* signal that the company is more interested in your money than your career.

4 Be wary of claims about high salaries. Successful models in small markets can earn $75 to $150 an hour, but the work is irregular. (See the Freelance Model section on pages 22-25.)

5 Ask for references. A legitimate business should have no problem with you contacting models who have secured successful, recent work based on the modeling school's training or the agency's work.

6 Check out client claims. If an agency says it has placed models and actors in specific jobs, contact the companies to verify that they've hired models and actors from the agency.

7 Be skeptical of local companies claiming to be the "biggest" agency or a "major player" in the industry, especially if you live in a smaller city or town. Most modeling jobs are in the larger cities.

8 Realize that different parts of the country have different needs. For example, New York is recognized for fashion modeling; Chicago has a large catalog market; Las Vegas uses many convention models; the Washington/Baltimore area is known for industrial or training films.

10 Ask your local Better Business Bureau, consumer protection agency and state Attorney General if there are any unresolved consumer complaints on file about the company.

11 Get everything in writing, including any promises that have been made orally. A legitimate business should have no objection to doing this. It is a big red flag if they refuse.

12 Keep copies of all important papers, such as your contract and company literature, in a safe place. This will help your case, should you ever need to file a complaint or even a lawsuit against the company.

13 If you think you've been scammed by a bogus modeling school, talent scout, agency, or photographer, contact your local consumer protection agency, state Attorney General, or Better Business Bureau. They're in your local telephone book.

"reputable agencies will provide you with plenty of time to research the business, check references, and come to a sensible decision."

council of better business bureaus

The Council of Better Business Bureau adds to the Federal Trade Commission's list with the following seven additional warning signs for disreputable agencies:

14 You should interview your agent as thoroughly as you would interview your doctor, lawyer, or CPA. Remember, the agent will be working for you, not *vice versa*. Carefully review your contract with your agent. This is your agreement regarding what the agent will do to earn the commission you pay.

15 Be leery if they request registration fees, consultation quotes, or administration fees up front. Legitimate agents work on a commission. They don't get any money until you get paid for doing the work they have obtained for you.

16 Most legitimate businesses spend a lot of time trying to come up with a business name that is unique and will differentiate them from the competition. Watch out for companies whose names are purposely similar to well-known agencies. Fraudulent companies will sometimes do this to give the incorrect impression that they are connected to a legitimate entity.

17 Most agencies would never even consider placing a newspaper classified advertisement to find models. Be wary of such ads that say something like, "new faces wanted" for commercials, movies or modeling, or claim that "no experience is necessary."

18 Do *not* let flattery and sweet-talk cause you to abandon your common sense. If you were approached in a common shopping mall, walk a distance away and surreptitiously watch to see how many other people the "agent" approaches with the exact same offer. Are they all likely to achieve fame as a super model or movie "star"? Or is this "agent" counting on making money in other ways?

19 Scams are on the rise. Requests to BBBs for reliability reports on various modeling/talent agencies has more than tripled in the past couple of years, an indication that more and more people are being approached with modeling "offers." Complaints grew significantly in 2001 and 2002.

Better Business Bureau complaint files show that fewer than half of all complaints against model/talent scout agencies are resolved to the customer's satisfaction. The BBB reports that this figure signifies that "The industry has more than its fair share of bogus operators who rely on misleading claims and promises to entice consumers."

20 If you need additional information, or assistance with a complaint against a business, you can locate your local BBB through the telephone book or via the national website at www.bbb.org.

5

the business of modeling

business savvy and a little insider knowledge will help you succeed

why an agency?

every aspiring model needs to find an agent if they want to work professionally. Larger clients who hire models simply don't waste time looking at "models" without an agency.

"If the person is good enough to hire, then they're good enough to be signed by a reputable agency," explains one industry source. "When I use an agency, I'm assured of being sent a person who knows the business, is exactly as promised, and most importantly *acts* professionally. If they're not with an agency I have to ask why? Would no agent take them? I don't need to waste my time on that."

The exception is the occasional "open call" or "talent search" that a manufacturer or clothing designer might run, but this is more of a publicity stunt than a general business practice.

Before we discuss how to pick the right agent or agency (pages 118-121), we need to highlight a few of the things that agents do for their models. In its most basic form, an agency creates

relationships with clients who might hire models, including magazine editors, clothing designers, advertising agencies, or manufacturers and service providers. If a model from the agency is hired, a payment rate is negotiated. The model then pays a percentage of the money earned (often 20%) to the agent.

Starting in the 1940s under the leadership of Jerry and Eileen Ford, the concept of the agent was expanded from merely signing and booking models to encompass "model management." Most agents today take care of collection from clients and advance the money to models, allowing them to have a more regular paycheck (and not have to wait the 90 or more days it usually takes the client to pay). Often this is called "guaranteeing their vouchers."

A reputable agency will also pay for everything up front, such as comp cards, messenger fees, and photography. These expenses are subtracted from future earnings, which means the model is not at risk of "holding the bag" should the agency fail to get him or her work.

Career deve
creation are
taken on by
discussed in

"The majori
with creatin
explains Ka
them a mar
how to dres
and teeth. C
have the ph
booking. An

"At Code M
models' da
booking ca
doctors and
says David
their model
and portfoli
for them."

"our job is to teach the models how to formulate a strong relationship with the client, so they get booked again and again."

david grilli, agent

Additionally the agent will act as liaison between the model and the client. It starts with finding out about castings, and sending them there with the right look. Once they're chosen, the agency does the negotiating to get a fair and proper rate based on how the client wants to use the image (see pages 131-133). They advance the fee to the model, and take care of the billing and tracking the payment.

"Most importantly, we work to grow a full career for our models," adds David. "For example, once we establish a model as a prominent entity, we need to take them to the next level. That level depends on the individual person. One of our models is being considered as a VJ for MTV's House of Style. So we need to translate everything she knows about fashion into the media of TV and film."

"It's a lot of work keeping people interested in your models all the time," explains Sam of Ford Models. "All the bookers work together, but we each still have individual models whom we are responsible for on a day-to-day basis."

In the example of the Men's Division at Ford Models there are six agents and one assistant. Everyone promotes the jobs that are in motion, but every model still has one primary manager. That manager is in charge of that model's career, schedules, financials, and marketing.

the right agency

"agents must be very level-headed. we know it's *not* a game and *not* a party. we try to keep our talent continually working."

sam, ford models

On pages 90-103, we discussed how to attract the attention of an agency, whether it is at a convention, an open call, or by sending in a photo. Once they have expressed an interest in you, it's time for a first (or second) interview. The purpose of this interview is to determine if you are right for each other— and you'll be interviewing the agency as much as they will be interviewing you.

However, assuming the agency thinks you're a perfect match, it is still in your best interest to do some research and shop around. The agency's reputation is paramount. If you don't know much about agencies, first do your basic homework to rule it out as a scam or con (see pages 106-111). Next do research at the library to find out if it has been covered in business periodicals and newspapers— and whether those stories were favorable or not. When you get close to signing, ask for references. These should be models currently signed with the agency as well as clients who hire their models on a regular basis.

Why clients? Because if the clients don't think the modeling agency is top notch, they're not likely to use them often. If they say they always call on this agency first, then that's a good sign too. But keep it in perspective. The agency isn't going to give you the names of unhappy models or clients as references. That's where friends in the industry can help, along with your own research.

Next, one of your other important decisions is whether you want to be in a large agency or a small "boutique" agency. There are advantages and disadvantages to both.

large or small?

Bigger agencies tend to have many of the better known models. They also have large divisions (also called "boards" after the bulletin boards found in their office, which hold the comp cards of current models). This means there could be 200 or more models in their women's division alone.

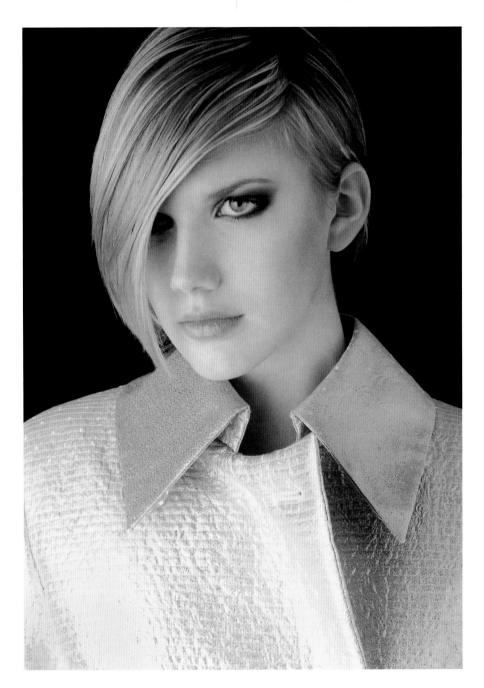

"it's not about getting the first booking; it's about getting the second or third. it's about getting rebooked." david grilli, agent

"some agencies should have diverse enough clients that they can carry one model from her teens, into the 'mom', and then into the classic 50+ market. *that's* a long-term commitment to the talent." top industry insider

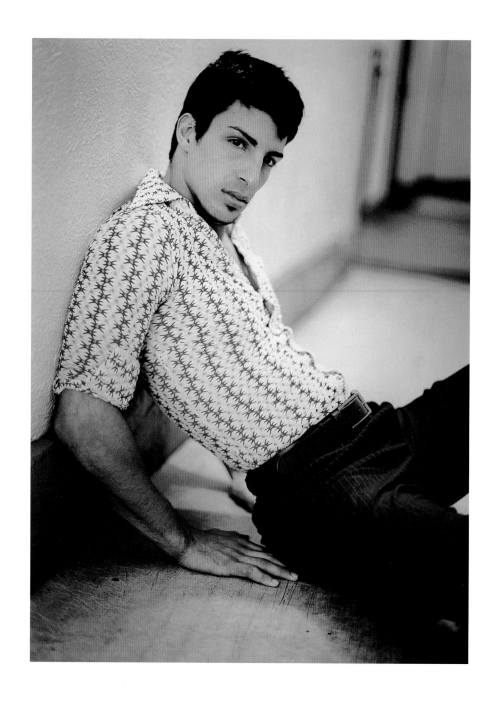

"Boutique" agencies tend to have a smaller number of models overall, such as 20 or 30 total models. Often they specialize in one or two types of modeling, such as Men Only or Fitness-oriented models.

The benefits of a larger, well-known agency are many. They tend to have more client contacts at a wider variety of businesses. An agency like Ford Models that has been around for more than half a century, has built up a client base that spans generations. This means they probably have more potential clients coming to them with potential opportunities, and they tend to attract many of the high-dollar jobs.

Therefore, there may be more casting calls offered to larger agencies. However, there will be far more models competing for those jobs within the agency, because all 200 people in one division would not be sent to a casting. You will also be competing with some of the bigger names in the industry.

A good boutique agency on the other hand may have very good relationships with a few key clients or be well known within their specialty. But the number of calls they get might be fewer, and some agencies may not be "on the radar" of certain clients.

However, with fewer other models to compete with internally, you might get a better chance of actually *going* to a particular casting than if you were at a large agency. This is because a potential client might call 30 agencies and say "Send me your ten best girls for a jeans ad." Those 10 models are going to be a lot different at a larger agency than at a smaller one, and you might be more likely to be sent out with the smaller agency.

So the real question becomes: Do you want to be a small fish in a big pond, or a big fish in a small pond? The answer is a very personal one.

other factors

Another factor in your choice of agency should have to do with the personal connection you feel with them. "There are so many different agents out there that it makes no sense for a model to choose someone who doesn't understand his or her personal career goals," emphasizes Sam, a booker in the Men's Division at Ford Models.

We suggest you ask yourself, "Am I just filling a niche with this agency, or do they really want *me*?" Don't be afraid to ask the potential agent why they want you, and what they see as your marketability. The answer will help you differentiate between agencies.

Other factors include your current age. If you're still a teen-ager, you and your parents might want to select the agency that is most supportive of balancing school and a modeling career. A smaller agency might give more personal attention to a model, or create a family-like atmosphere with emotional support as well as business support. Alternately, a large agency might have a large "new faces" type of program where there is the camaraderie of a dozen or so similarly aged new models.

"The Men's Division at Ford Models has stayed on top for so long because we've never lost focus," argues Sam. "We cater to a worldwide market with clients that range from Gucci to K-Mart.

"You may be young and edgy and perfect for *French Vogue* today," he adds. "But in a few years you'll need more commercial clients— and we have *everything*."

Katie Ford, president of Ford Models, concurs, adding that this is why their agency manages models that range from babies through their 70s.

no agency?

Having said that the first step to becoming a model is to get an agent, we're going to add this caveat: It is possible to get occasional jobs without an agent, especially if you're in a smaller city or doing specialties like Swimsuit and Babies.

However, and this is a big however, most of the clients willing to work with an agentless model pay extremely low or no money. For the client hiring models, there are numerous advantages to using an agency (see page 114-117), but only one disadvantage— the agency fee (which is an extra 15 or 20%often tagged on to the modeling rate). Therefore, they'd go outside the agencies only if they had an extremely low budget or they were trying to find someone with a more unusual look (and couldn't find them in the local agencies).

Without an agency, you have to do your own marketing. Internet modeling sites, where you post your portfolio pictures, is one option. We heard from several semi-pro models (see pages 22-25) who got occasional jobs through this. Most were low- or non-paying, but a few were at more "regular" rates.

Another more traditional method is knocking on doors. Determine which companies might hire models, and then find out who in the company does the hiring. Approach the local advertising agencies and the professional photographers and let them know you're available.

Don't be surprised if these potential clients ask you, "Why aren't you with an agency?" because that is the industry norm. Unfortunately, they will often assume it is because you're "not good enough" to get an agency, which in turn may make them view you as less talented (consciously or subconsciously). After all, there are few disadvantages to having an agent.

"Few disadvantages? Don't agents get 20% of my earnings?" might be your question at this point. But the agent does a lot of the time-consuming work for you. If they're good, they've been working for years to build relationships with potential clients. These relationships can get you jobs that you wouldn't have been able to get yourself. Hence, instead of thinking they're taking 20%, you should view it as they're bringing you 80% that you might not have otherwise gotten.

"do you want to freelance part-time for 'fun' or do you want a real career? I don't know any models who can work full-time without an agent." eric bean, photographer

Darryl Brantley of *Vanity Fair* magazine counters that small agencies can be beneficial. "Some larger agencies over-modeled themselves. Managing 300 women in one division is insane because it becomes hard to give each person individualized attention."

smaller markets

Even in smaller cities, such as those with populations of one or two million, the agencies will still have large boards, perhaps with over 50 people in the Women's Division. After all, it's not hard to find 50 aspiring models, and they want to make sure they have all their bases covered.

In other words, they want ten beautiful Latino women; ten beautiful African-American women; ten beautiful Asian women. Even among Caucasians, they want a few women of each specific type— short hair, long hair, curly hair, red hair. That way they're confident they have the specific look the client is asking for, every time they ask.

Unfortunately, these smaller markets don't have the quantity of jobs or the higher paying jobs that you'd find in New York, Los Angeles, Chicago or Miami. So the work (and the money) gets spread a lot thinner

between those 50 people. On the flip side, it is a lot cheaper to live in a smaller city, so a lower income may not be an issue.

Another bit of good news about smaller cities is that the height and size requirements for models may be much more relaxed. If you can't get into an agency in one of the major markets, or you don't want to live in those cities for personal or professional reasons, there are plenty of smaller cities across America that can support a handful of models full-time, and many part-time.

The best of these smaller markets have a strong local industry or a major corporation headquartered there that fuel a local market for models. For example, a major corporation headquarters may shoot their own annual reports, catalogs, and advertisements locally.

Top models in a smaller city can often earn a comfortable living, such as $30,000 or $40,000 a year— or perhaps more. If the cost of living in that town is favorable, that salary would go a lot farther than it would in New York City, where rent on a tiny one-room apartment might be $1000 or more!

The vast majority of the work in smaller markets is Commericial Print. As discussed

on pages 38-41, Commercial Print models tend to look a little more like the average person, because they will be depicting roles such as Mom, the girl-next-door, or the corporate executive.

local agencies

Smaller cities have agencies. Sometimes big name agencies in major markets have agreements with these local agencies, and their "stable" of models is regularly reviewed to see if there are any rising stars who might do well in a larger market.

A good local agency should know all the local businesses and corporations that potentially hire models, such as a major manufacturer that needs a brochure or a department store that needs catalogs and advertising photos. If you have the look they need, you'll probably get nice, regular work.

You may be able to do freelance work without an agent. See pages 22-25 for more information on this.

Unfortunately, smaller towns are the most likely place to find the scam and quasi-scam agencies, schools, and photographers— so keep your eyes open.

signing with an agency

Once an agency and model agree to work together they usually sign a contract or "agreement" that commonly lasts two years. In the past, contracts had money guarantees, but today they usually don't. They are an agreement between the agency and the model, that agency will be their exclusive representation for a specific period of time.

Most agency contracts stipulate that the agency will take a percentage (usually 20%) of the earnings when the model works. In exchange, the agent "guarantees the vouchers" and pays them for their work in a timely fashion (see page 114). The agency also agrees to manage them to the best of their ability.

Expenses such as photography, comp cards, messenger fees, and more, are usually fronted by the agency and deducted from the model's portion of the client payment. Don't be afraid to discuss these agency fees and any other money issues openly, both before and after you sign a contract.

Remember the key phrase "to the best of the agency's ability" or "best efforts" when you sign the contract. Even if it is not written into the contract it may be implied. If you later feel the agency is being negligent in representing you, this may give you an opportunity to bow out of the contract and sign with an agent that is more attentive to your needs.

Keep careful records of your expenses and the actual services the agency has delivered, including the number and quality of casting calls and jobs you have gotten. Should you have problems, good records will be powerful ammunition for your cause.

However, be realistic in your expectations. Though "instant success stories" occasionally happen, it is not the norm in this business. It will usually take a substantial period of time to build up steady business, even with the best agent.

Unfortunately, many models assume that once they sign with an agency, they have it made. But even signing with a big-name agency does not guarantee anything. It comes down to your relationship with your agency, current trends and just plain luck.

"Once a model signs with an agency, it usually takes a good 6 months to a year to really get developed," says Sam. "You might get some small jobs, but most models don't make a full-time income at first."

This explains the cliched waiter/model. An evening job waiting tables allows you the flexibility to go to casting calls in the daytime, until you build up enough regular modeling work.

"There is a ladder in modeling, just like any other business. It's a progression. You have to work on your cachet, and move to bigger and better jobs," says Amie Hubertz.

"I've been lucky," she adds. "Since I've been modeling, I've made more money each successive year. But many models peak at a young age and are completely out of the business in just a few years."

"being signed with a name
agency is not necessarily
going to make your career.
not everyone has that
fabulous superstar story."

darryl brantley, vanity fair

the agency relationship

> "the model needs to look at the agent as his or her team captain."
>
> david grilli, agent

Technically, your agent works for you. *You* are their client in theory. However, if you go into the relationship (and it is a relationship) with that attitude, nobody will win.

It's a team effort between model and agent. When a model is listening to the agent's counseling it can be very productive. After all, if you've picked the right agent, then they will have years of experience and numerous lucrative potential clients in your area of specialty.

"It is collaboration," explains Sam. "We do technically work for the talent (the model), but it is a work-together kind of relationship."

It's basic human nature that the more the agent likes you as a person and respects you as a professional, the harder they will work for you. Anyone who has ever had a bad boss or a poor sports coach will know that the business or sports team suffers as a result of the bad relationship.

"You've got to like your agent and they've got to like you," emphasizes model Todd Riegler. "If they don't like you, you may find that other models are chosen to go out to the best castings."

"And I say *like* you," he adds, "I mean really, really like you. Like you as a person, like you as friend, like you as a model, like you as a business asset to the company."

Another business-savvy model adds: "I keep a notebook with important information about agency personnel, and especially my individual manager. I know their birthdays, as well as the names of their immediate family or people important to them."

This model makes sure to ask about their family members by name (especially children) in casual conversations, and sends cards and flowers if someone is ill.

"Treat them as if they were one of your closest friends, and do everything for them that you would do for a close friend," advises the same model.

become an asset

A point that deems repetition is that the agent should consider you an "asset to their business." Even though the agent technically works for you, you are representing them when you go on a casting call or a job. Just the fact that an agent sends you to a client means they have assured them that you will be professional, well-mannered, and up to the industry standards in terms of beauty and abilities. Anything less and the *agency* would look bad.

If you were to make a bad impression on the casting director, the art director, editor, photographer, or even the stylist, you would cause everyone to become leery of using *any* model from that same agency again.

Likewise, an agent who is not professional with the casting director or model booker can ruin your career, because these clients certainly won't want to have to use that agent again. Hence it is a team effort, with both parties making every effort to do well.

small world

"Even though the agency world is very competitive, it's very friendly and very small," confirms David. "We scout together and spend weekends together on the road. I have several of my best friends working at competitive agencies."

Whenever a model leaves an agency, it's usually very mutual. When an agency is unhappy with a model it is usually has to do with her personality or how she performs on the job. If she leaves, chances are another agency is going to hear that she's a "problem child" and not want to use her either.

professionalism

a business topic that cannot be overemphasized is professionalism, yet even in business schools it is not addressed well.

Darryl Brantley recalls the story from when he was a model booker for a major fashion magazine. He had hired two models for a shoot with a famous photographer. Shortly after the shoot began, the photographer decided she liked one of the models better than the other, and would shoot that one alone. The other model was told "Thank you very much, but you're done for the day."

Instead of being gracious, leaving politely, and happily cashing her check, she called her booking agent from off set in tears over the "rejection." The booker then called Darryl, pulling him away from the shoot, to ask what was wrong and why didn't the photographer want her.

Rejection is a huge part of the day-to-day life of a model, but being able to handle it appropriately is a major part of the concept of professionalism. If you hang your entire sense of self-esteem on whether you're chosen or not for each potential job, you'll never survive. (See page 157 for more information on handling rejection.)

"It was just a business decision," laments Darryl. "But instead, this model made it into a *huge* drama. The sad part is that she ruined her chances to work with me, the magazine, or the photographer again."

chain reactions

This story also emphasizes the chain-reaction affect of unprofessional behavior— whether it rears its head as bad manners, immaturity, inappropriate behavior, lateness, drug use, or other unacceptable behavior. In one fell swoop, this model alienated everyone on the set through her immature behavior.

There can be as many as 30 people at a photo shoot. People in general tend to talk and gossip, and they remember the bad experiences *and* the good instances. The modeling industry is not immune, and is perhaps worse than most industries because many of the players are freelance, working with new people each day. Tomorrow, those 30 people on set may be working on completely different jobs with completely different people. When discussing the casting for the next job, if it

"the most common trait among successful models is their professionalism."

david grilli, agent

comes down to six models being considered, just one negative comment about you that rises up to the surface could knock you out of the running. Alternately, if someone recalls something good about you, you're likely to be pushed to the top of the list.

"I have a few models that always send cards to people who have hired them, thanking these clients for choosing them as the model. For a big job they might even send flowers," reports David.

This show of appreciation makes good business sense. These same models will then send holiday cards at the end of the year to every one who has hired them. "They come off as looking like a class act, and they get used again and again," adds David.

"I was always surprised during a casting if some of the models were a little rude or snotty," says Darryl Brantley. "I'd call the booker and ask 'Who is the bitch you sent up here?' If enough casting directors complain or make comments, you can bet that model's contract won't be renewed."

Keep in mind that it is a fine line between being polite, positive, and nice, and being insincere. You don't want to paint it on too thick. You really have to love what you're doing and be happy to be there, because casting directors and model bookers will be able to see right through any insincerity.

That doesn't mean you have to love every minute and every aspect of modeling—that's impossible. But you have to want it so much that the not-so-fun portions (like endless casting calls) can be handled in a good mood with a positive attitude.

"If you think modeling is a quick easy way to make money, then you're getting into the wrong business," says Sam. "The models that do well are the models that feel like they *have* to be a part of this business.

five signs of professionalism

1 Good Manners: Saying "good morning" and "thank you" go a long way! Basic pleasantries are sometimes forgotten if you get too nervous.

2. Timeliness: If you are late to a casting, the client will worry that you may be late to the actual photo shoot as well!

3. Preparedness: Your portfolio should be up-to-date when you go to castings. And you should be prepared for the type of job you were hired for. This includes being well rested and arriving ready to work.

4. Attitude: Willingness to work, exuberance, and a good positive outlook are an extremely important aspect of professionalism. No checking your watch or complaining if the hour gets late.

5. Follow-up: Businessmen and job-hunters know the importance of thank you notes— modeling is no different! They could have used any one of a hundred models for the job, but they chose you.

There is something inside of them that makes them yearn to do it, and they give it everything they've got."

Model Carmen Dell'Orifice agrees: "If anyone goes into the modeling business to make money, I advise them to stop right there. There are only a few of those big contracts. All that beautiful editorial work? You get paid almost nothing for the mere *privilege* of working for the magazine!"

money matters

"learn to count early.
don't spend what
you don't have.
and never let
anyone — even
your parents —
totally take over
your finances."

carmen, model

aspiring models should have a good sense of money matters before they enter the business, even if they are teenagers. At the simplest level, you need to understand the money relationship with the agency. As mentioned earlier, an agency takes a percentage of the model's earnings (usually 20%), in exchange for the services rendered.

In addition to coaching the model and helping her get jobs, another crucial role is to negotiate the modeling fees for each individual job. This is extremely important, because there is no single set hourly wage for "modeling."

Modeling rates are based on how the images of the model will be used. For example, most aspiring models are surprised to learn that editorial work in the major magazines pays very little. A cover of a top magazine may pay only $150— not exactly the multi-million dollar paychecks you hear about in the tabloids.

Advertising work pays more, and the rates are based on where the pictures are

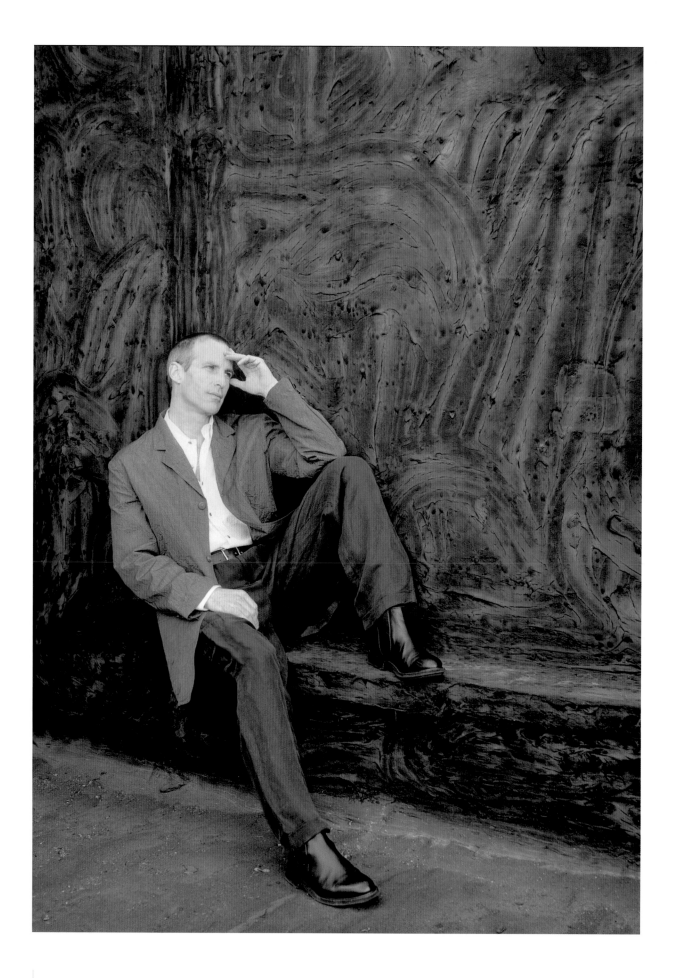

"I'm not trying to kill your dreams, but you've got to dream smartly — and stay awake!" carmen, model

do the math!

$150 for the cover of a major magazine might sound like a lot if you're currently earning minimum wage. But it is important to realize that this rate is divided by the number of hours the shoot takes.

Then you have to add in the number of hours you spent going to castings you didn't get (for which you aren't paid). And don't forget the hours spent at the gym staying fit, dance classes, research on current trends, record keeping, and more.

At the end of the year, divide all your paychecks by all the hours you've spent trying to get the jobs, and preparing for the jobs. This will give you a more realistic hourly wage.

If you live in New York City (and you'll probably need to if you want the best jobs), $150 doesn't go very far. Your rent alone could be over $1000/month for a tiny one-room studio apartment!

published, or on what level. For example, an advertisement that will only run in a small local newspaper would pay far less than the same picture used in a national advertising campaign.

Catalog photography varies as well, and is often based on a day-rate, in which there are numerous photographs taken as quickly as possible. Catalog work can yield a very consistent paycheck and make up the "bread-and-butter" of many models' annual income.

Rates also vary upon exclusivity. In the cosmetics field especially, top models often take "exclusive" contracts with one company. This means they agree not to appear in advertisements or editorials using or wearing a competitive brand for the

duration of the contract. The agents are able to negotiate much higher rates for exclusivity.

The hottest runway models can earn an incredible $20,000 for a 2-hour show ($4000 of which goes to the agency). This same model may work certain other shows for free because of the exposure it gives them, helping them work toward a certain image.

For the same reason, top models are willing to work at the incredibly low editorial rates of magazines, because being on the cover of the right magazine will make them seem "hot" to more lucrative advertising clients.

It also makes for great "tearsheets" (pictures of you torn from magazines,

advertisements, or catalogs) in your "book" (the portfolio you show potential clients). If you only have original photos to show at a casting, the casting director will wonder if you have any experience. Tearsheets are proof that you have worked before and aren't a complete and total novice.

Big money clients like to know you have a little experience, because if they're putting a large amount of money into buying advertising space in magazines and other places, they want to make sure you can pull the job off. They can't afford to reshoot, so they're sometimes reluctant to use someone too green and unproven. A more experienced model knows how to work on set and make the products being sold look their best.

marketing your image

the average model has to work their way up to bigger clients and more prestige. Magazines like *Vogue*, *GQ*, *Elle*, *The Face*, *ID*, and *Harper's Bazaar* carry a lot of prestige, and they are the goal of many fashion models. Even though they don't pay well, the visibility they can give you is crucial to getting higher paying jobs.

The trick for the agent who is guiding your career is to try and balance the big money jobs with the high-profile but non- or low-paying jobs.

A second challenge is to avoid typecasting. If the agent is trying to develop you as an edgy, high fashion model, they might not send you to a casting for a J.C. Penny catalog, because it is such a different demographic than Gucci or Armani. They might not want future clients to think of you as a catalog model. However, if you have a more wholesome, mid-American look that is not edgy enough for "haute couture," that same catalog might be a very wise career choice for you.

longevity

Your agent should be looking at your long-term goals in addition to next week's jobs. A good agent will help you determine your total career (and life) goals. Don't be scared to discuss these goals, and solicit your agent's advice about how realistic or unrealistic your expectations are.

As you get older, your marketability also changes, sometimes for better and sometimes for worse. "It's a business where you have to be constantly evolving your look," explains David. "I think that a model can work for a very long time and have a full career if they are honest with themselves about where they are at any point in their career."

"At 35, you are not going to be an editorial model for *Vogue* anymore. But there are 35-year-old models who make very good money because they're realistic about their marketability. They move to more mainstream clients, becoming 'the mom' in a pharmacy or cereal advertisement," he adds.

The work David Grilli is describing is usually catalog modeling work and commercial advertising work. People in America won't know the names of these models, but many are earning $200,000 or $300,000 a year. If you're looking at modeling as a job and career, you'll be very happy.

"Some of our most consistently working models are in the Classic Division," adds Katie Ford, Ford Models. These are women in their forties and fifties who are getting consistent, well paying work.

"I've been modeling since my teens, and my agent says there is still a lot more money out there for me," says Amie Hubertz. "As I get older, it will open up more doors— it will close some, but it will open up still more."

marketability

Age is not the only factor affecting your marketability. Some models have a cutting edge look that might fit the current trend in high fashion, while others have a more wholesome look perfect for the teen magazines like *Cosmo Girl* and *Teen Vogue*.

"Models need to drop any preconceptions and fantasies they have, and listen to what their agents are telling them about their potential role in this industry," explains David.

As seen in Chapter 2, there are numerous specialties. It is the agent's job to figure out which specialty fits you best at each point in your career.

"no agent has a crystal ball.
a lot of elements have to come
together, and sometimes it takes
a few weeks, but more often it
takes a few years." david grilli, agent

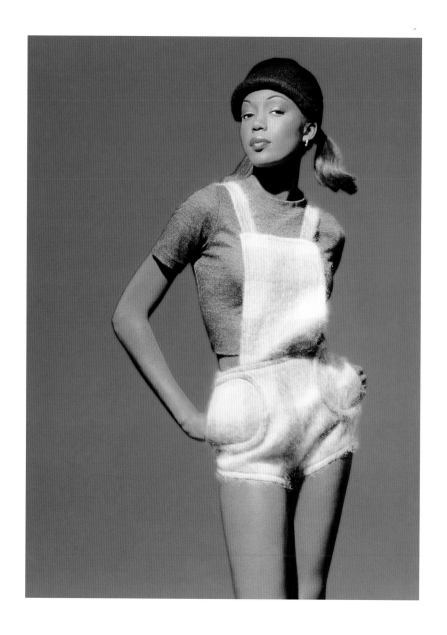

"you should only become a model if you wake up every day and think 'what can I do that will make me better at this?'" carmen, model

"You might get more fame and notoriety in the High Fashion markets, but you'll probably make a consistently better annual income in Commercial Print," says another agent.

If you're going into modeling for the fame, then you're probably in for a huge disappointment when you realize it's not just simply about being the "cover girl."

Wise for her age, model Lindsey Kraft had realistic expectations when she started at 16. She was ideal for the Teen market (see pages 36-37) because of her incredible smile and friendly look. Also, at Size 4 or 6

she was too large for Runway work and too curvy for High Fashion.

Though she hasn't been able to achieve the name recognition and "fame" that comes from the prestige of High Fashion editorial and Runway work, she has earned an impressive annual salary over the past several years— while completing high school *and* college.

Amie Hubertz is a model who is savvy about her role within the industry. "I'm a complete freak," she jokes. "I have red hair, I'm six feet tall, and I'm not tiny-skinny."

Her agent has always told her that there are very few really great natural red-headed models. The red hair is often a disadvantage because the client is usually looking for either the more common blonde, brunette, or African-American, *or* for a more unusual and exotic ethnic look.

"I'm like the field goal kicker on a football team," she explains. "A lot of the time I sit on the bench, which is frustrating. But when they need my specialty, I'm in a great position to get the job."

transition to acting

"there is a lot of 'acting' in modeling, so it has been an easy transition for me."

lindsey kraft, model

a goal of many models is to make the crossover to acting. Models like Cameron Diaz and Lauren Hutton have moved on to successful movie careers.

Some agencies bring acting jobs to models, often through the same clients as the still photography. An example might be a Commercial Print client for a cosmetics brand who decides they'd like to use the same model in their advertisements on television.

Usually the "exclusivity" clause of an agency contract (referred to on page 124 does not include television and film work. Models often take on agents that work exclusively in these fields, because they have the right contacts.

Teen model Lindsey Kraft maintains her modeling agent (Code Management), but also has an acting agent (Innovative Artists) who helps her get television work. She has already been featured in an episode of *Law & Order: Special Victims Unit*, the soap opera *As the World Turns*, and a television pilot for Paul Reiser.

"There is a lot of 'acting' in modeling, so it has been an easy transition for me," she explains.

She also loves the fact that it is a totally separate industry. "I can come in as the girl-next-door instead of the stereotype of the model-turning-actress," she says.

A good place to start is in the "Under 5" category, a term that originally referred to under five lines. In the heavily unionized television acting industry, you can do an Under 5 part without being a member of the AFTRA Union, so long as you join within a certain period of time.

Saturday Night Live (*SNL*) is television show that will occasionally use models in their sketches. It doesn't pay much, but it is prestigious footage to put on your "reel"—

"an actor's headshots are about character and expression, whereas a modeling portfolio shows the best possible version of yourself."

sebastian lacause, model & actor

the film and television version of your modeling book.

Brian Siedlecki, a talent executive with *SNL*, explains that the television and film industry is similar to the modeling industry in that there is a hierarchy. Most people start small and build up the reel. "The better your reel gets, the better jobs you'll get," he says. "It's all about building up your cachet."

"It's important that you give 100% even if it's just a tiny role as an extra," adds Brian. "Sometimes you get bumped up on the spot as a script changes."

Just like the players in the modeling world, the players here have a long memory too. If they like you or hated you, they'll remember and it will affect future bookings.

Brian also reported that he was bemused by the attitude of some models. There is a big reality check when a model shows up to a TV show. They're shocked that they are not the center of the action because they are used to having the entire shoot be about *them*.

"Most of these models make more money breathing than they do in a TV sketch," he jokes. "So it's a big adjustment. They're expecting their own dressing room and a hair and makeup artist. Instead they're sharing with a dozen other people."

"On a show like *Saturday Night Live*, it may be about them for one joke, but then they need to scoot off set and we move on," explains Brian.

Another reason for taking Extra and Under 5 parts is to get experience, and to see if you like it or not. Live television is especially different than the modeling environment.

"We've had inexperienced people walking around the set during rehearsals like it's their living room!" complains Brian. "You need to stay on your 'mark,' do your job, and then leave the set promptly so you don't get hit by the camera crane when it swings around for the next angle. This is live, and you don't get second chances."

Another stumbling block for many models who want to become actors or actresses is that acting is not always about being beautiful. It's about portraying a character.

"It's hard for most models to realize you do not have to look perfect at every second," reports Brian. "It's important to keep up an image, but to what degree? You should look good, but if you have to mess up your hair a little for a role, it's worth it."

"Cameron is great because she is willing to make fun of herself and go all out," explains Brian of Cameron Diaz, a model who went on to host *SNL*. "She wasn't worried about how she *looked* in every

sketch. If she has to wear a funny costume and not look 'model-perfect' she will."

If you decide to pursue acting, your acting agent will help you create the head shot you will need for your acting comp card. These pictures are often very different than the images you'd put into your modeling portfolio.

Sebastian LaCause, who has co-starred in the Broadway musical *Rocky Horror Show*, explains: "An actor's headshots are about character and expression, whereas a modeling portfolio shows the best possible version of yourself."

"It comes to the point where if you couldn't look like that headshot in five or ten minutes, don't show it to me," says Brian. "This isn't still photography, where we have the whole day to get just one shot."

Casting directors tend to get frustrated if the actors that come in look nothing like their photographs. "If ten people show up and five don't look anything like you expected, it's just a big waste of time," adds Brian.

Sebastian also points out that actors have much more control at their auditions with monologues and scene readings. "In contrast, a modeling casting call is much more of an instantaneous "yes" or "no" when you walk in," he says.

it's your career

after discussing in this chapter how important it is for you to let the agent help you determine what specialty you should be working in, we need to add this caveat: It's your body, your life, and your career, so you always have the last say. Listen to the advice given to you by the experts, and then make the decisions that are right for you.

Though you might hope to be a model "forever," you need to plan for other options, because (and this is becoming a refrain you'll hear over and over in this book), *nothing* is guaranteed. As a 14 or 15 year-old, you may currently be "model material," but your looks, height, and size might change considerably as you mature, causing you to drop out of modeling in one to five years.

Alternately, you may find that you don't enjoy it and look for a different career. Many teens quickly learn that the day-to-day routines are a lot more work (and a lot less fun) than they imagined.

"For a multitude of reasons, your modeling career may be considerably shorter than five years," says one industry insider. "Not everyone can pull a 20-year career out of it."

In addition to your body changing, the industry itself changes at a rapid rate. The preferred "look" changes on an almost annual basis making *your* "look" more or less popular.

This makes your education paramount, and you need to make sure your agent shares this concept. For example, don't be tempted to drop out of high school at 16 because you have enough work to do modeling full time. You may very well find yourself out of the business at 21, without even a high school diploma to fall back on.

Lindsey Kraft, who started at 16, had an agent who helped her balance modeling jobs with school work. "My booker always helped me sort through which were the really important castings and jobs," she recalls. "There was only so much school I could miss and still keep up good grades."

Not every agent will look at the big picture. You may be a mismatch with your agent if you find they are pushing you to go to endless castings regardless of your school schedule, or your personal, emotional, and family needs. If this is the case, it is likely they are thinking only about their 20% commission for the day, and not about developing you for the longer journey of your entire career.

Some models, especially those in their teens, also may not want to do the traveling needed to establish them in the world of high fashion. Others may not feel comfortable doing runway work in front of a live audience.

Still others may draw the line at lingerie or nudity (see pages 142-143). If you're not comfortable in a bikini on the beach, you probably won't be comfortable (or look comfortable in pictures) at a lingerie shoot.

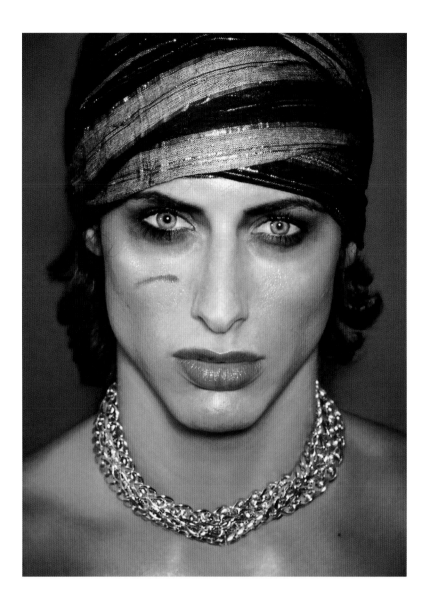

If you have a good agent, they'll listen to what you need both for your career and for you as a person. Decisions like this can be difficult for any adult. If you are still a teenager, making decisions that will affect your entire adult career can be especially difficult. It requires that you "know yourself" and listen to the inner voice.

The bottom line is that you have to be happy doing what you're doing. It's an unpredictable business with no guarantees, filled with more rejection (castings you "lost") in a month than most people face in their career.

Over and over we heard from models, agents, and casting directors that you have to keep it all in perspective. Modeling is just a *job*. And not a very secure one.

Even if you are stunningly beautiful, the inconstant trends of the industry could take you from being incredibly popular one season to totally undesirable the next. You haven't changed, but the industry has changed. Usually, the rejection isn't *personal*, and there is nothing you could have done to "improve" yourself. Taking this to heart requires a tremendous amount of self-confidence.

"When modeling was the main focus of my life, any casting where I didn't get the job was devastating," reveals one model. "I found the unpredictability of modeling horrible, and I was constantly setting myself up for disappointment. But now that I'm more focused on college, my family and my boyfriend, I can look at modeling as just a job— and a *very* fickle job at that. So that today when I do work, I appreciate it that much more."

"it's a business where you have to be constantly evolving your look." david grilli, agent

nudity in modeling

there is no question that you will find nudity in many of today's American advertisements and magazines. Go to Europe, and it is even more prevalent. However, as a model you will have the choice of whether you want to pose nude, partially nude, or even in lingerie. Despite myths and rumors, you can have a successful career in modeling without posing nude.

This does *not* mean you can be shy about your body. "You really need to be comfortable in your own skin," explains model Jodi Kelly. "As a runway model, there is just no time to be modest and you have to change outfits in front of every one else who is backstage."

"Even on a normal fashion shoot, you'll have stylists touching you to pin or tape outfits. The makeup artist may have to apply makeup to every inch of exposed skin. You need to become comfortable with it, or you'll never survive as a model."

It is also important to distinguish the very big difference between a photographer who is trying to create a sexy image and one who has inappropriate intentions.

sexual advances

Despite Hollywood's depiction of photographers, it is very rare for a fashion photographer at a shoot with a professional model to act at all inappropriately. The industry is just too small, and they would have trouble getting work once word spread! Most reported problems occur on the fringes, in the "freelance market" where sleazier characters can take advantage of inexperienced, aspiring models.

"The whole thing about modeling is that you want it so bad, it's easy to lose perspective," says Jodi. "You go on castings and then they *choose* someone. And you want to be the one chosen."

This can play on the insecurities of young models, making them more vulnerable. A new model should not lose that inner voice that warns that you might be getting into an uncomfortable situation. If sexual advances occur, simply express that you find them inappropriate. If they continue, just leave. There are other jobs.

Even if it is just a matter of feeling uncomfortable in a see-through blouse, Jodi emphasizes that it's perfectly acceptable to tell the photographer that you are not comfortable with it. "Something can always be worked out," she adds.

you & your agent

David Grilli of Code Management explains: "Nudity is always discussed in advance of signing a contract with a client to book a model. It has to be pre-approved if there is even going to be swimwear or lingerie involved."

As a result, most agents have had planning sessions with the models they represent to determine their parameters concerning nudity, so they'll know which jobs to turn down. There is a big difference between a classic, tasteful nude silhouette for a skin or fragrance advertisement and pornography, so be specific with your agent.

"You and your agent need a clear vision of how you want to market yourself to potential clients. *Playboy* has been known to call agencies. It pays well and it's another form of modeling. But you need to decide if it's right for you and your career," adds Grilli.

When doing photo shoots that require full or partial nudity, most bookings stipulate a *closed set*. This means that when it's time to disrobe to take the photographs, only the essential staff are present— which usually means the model, the photographer and perhaps a photo assistant. This allows the model to have the most privacy available to achieve the shot.

"on a legitimate photo shoot, nudity is *never* a surprise. it is always discussed with the model and agent before the job is booked."

eric bean, photographer

above
Long before the first job, the model and his or her agent discuss the potential of nude, partially nude, and even lingerie photo jobs. Many models prefer not to do these types of photographs for personal reasons, or because of their long-term marketing plan.

6

working as a model

from your first casting through your first job

your book

"my body isn't perfect, it never was. but in photos I project an illusion of perfection. it's a performance." carmen, model

One of the major tools of the trade is your "book." This is a portfolio with pictures of you, and tearsheets of work you have done (usually pages torn out of magazines). When you first start out, your entire book may only have a Polaroid photo taken of you in the agent's office. There are plenty of stories of models who have landed huge jobs with nothing more than this. However the vast majority of models start with this one Polaroid and start building up their book.

Your agent will help design your book with appropriate photographs. It's not uncommon for the actual portfolio case to have removable pages so you can add and reorganize the pictures to cater the book to the exact clientele of a particular client.

Often, a model's book will encompass many different styles and poses, so that there is a better chance that the person reviewing it will come across something similar to what they are trying to do.

Most show variety, not just in terms of clothing, but in terms of expressions of the face and body, as well as the overall mood of the photograph. Depending on the market, they might include pictures that show the model interacting with friends or children, in addition to the more common solo pictures.

Model Todd Riegler likes to move the most appropriate shots to the front of his book. For example, if he knew the casting is for a model who will depict a businessman, he'd move his more executive-looking shots to the front.

Resist the temptation to show several images from one shoot, with just small variations in pose or look between the photographs. If they're too repetitive, it's much better to use just the best one. Not only does it waste the casting director's time to have to flip through the extra pictures, but it dilutes the impact of the original image.

Avoid photographs where the highlights are so blown out that no details in your face can be distinguished. It might be a beautiful photograph, but it gives the model booker or casting director little idea about what you *really* look like.

Take care when including nude photos in your book. Even swimsuit photos are advised against by some agents because they can sometimes carry a "cheesecake" stigma. This could work against the image you are trying to create.

Your book will be in constant transition. Not only will you be adding better tearsheets and photos, but as your look or specialty evolves, the photos that serve you best will change.

"Models are always changing their portfolio," explains Katie Ford, Ford Models. She emphasizes, for example, that a model in their 30s or 40s will be going for more commercial work, rather than fashion editorial, and their book should reflect that by showing less "fantasy" and more real-life images.

"At a casting, they just flip through your book, occasionally looking at a single page for a moment or two if it is similar to what they'll be shooting," says Todd. "It's really hard to not get annoyed because they're just breezing over something that took *years* to develop. But you have to remember that it doesn't matter how beautiful the photos are, it's still just a hiring *tool* for them."

Todd of course would never show this disappointment or annoyance to the casting director. They have to see dozens if not hundreds of potential models, and cannot possibly take the time to "enjoy" each photo or hear the story behind it. If they look at the book for 30 seconds, you've done well!

test shots

"it's a performance…, a communion…, an agreement for the model and photographer to come together in that lens." carmen, model

O nce you're with an agency, a common way to get images in your book is the "test shot." Test shots are a mutually beneficial event for photographers, models, and agents. Like models, photographers are also always trying to improve their own portfolio, so when they have free time they may shoot creative images to add to their book. This is the time they try new techniques or experiment with creative concepts.

Body model Todd Riegler was very proactive with photographers to increase the number and quality of the photos in his book when he first started out. "I'd network with *everyone*, and try to get good photographers to do test shots with me," he says.

The images of Todd on pages 12 and 51 resulted from one such test shoot, and became a prominent photos in Todd's book.

Since the photographer doesn't have a client footing the bill, they don't want to have to pay a model. The model is likewise trying to get great images for their book, so they agree to pose for free. The model usually still has to pay for the printing of images they want, but the day rate of the photographer is not charged.

Check with the photographer ahead of time about outfits, hair, and makeup, because unless they're bartering in a similar fashion with a makeup artist,

left & right
Fashion photography is all about fantasy, so makeup artists like Cyrus have creative license and sometimes use wonderful, bold colors, as can be seen in these before (previous page) and after (right) photographs.

hair, and clothing stylist, you'll be doing it yourself.

If the photographer wants you to sign a model release (which gives them permission to sell the images to anyone without further compensation to you), check with your agent first. It is not an uncommon request, but any time you sell or grant rights to your image, you're making a business decision that could have ramifications on your career.

An added bonus of the test shoot is that if the photographer has a pleasant experience and *loves* the way you photograph, he or she just might recommend you for a future job, especially if it is similar to the test shoot.

Jump at any opportunity you have to shoot with a top-tier photographer. If the right one latches on to your face, you can get quickly propelled to the top of the list. Aside from the time spent, you have nothing to lose from a test shoot, since you only pay to have prints made if you like the shots. And you never know what creative images might come out of the session.

The goal of this shoot was to use makeup, hair, and lighting to transform the model into a vision reminiscent of Jean Harlow.

Makeup artist Cyrus tweezed model Deana's eyebrows and then painted in a very distinctive, designed look. The final touch to his bold makeup was a mole.

The photographer created both black-and-white and color versions of the same basic lighting setup.

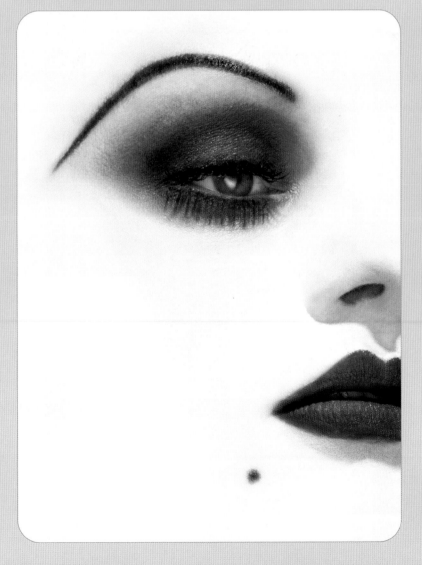

"the face is a canvas and I paint fantasy. I do it from my heart, and look at it as an art."

cyrus, makeup artist

casting calls

"hundreds can show up for 'cattle calls,' so your chances are slim. but the more times you meet a casting director, the more likely it is they'll remember your name."

If your agency is doing their job, they'll be setting up casting calls for you on a regular basis. These can range from a private one-on-one appointment to a massive "cattle call" where hundreds of models get in line to have a few moments with the person or people making the decision. The person in charge can be the model booker from a magazine, an in-house casting director for a corporation, an art director from an advertising agency, or the photographer.

There are only seven rules to a successful casting call:

1 Ask your agent to get as much information as possible about the casting. *Who is the client and what are they like?* If someone else has worked with them at the agency, you can find out what to expect. *What are they shooting?* If it's lingerie, you should be ready to strip down and pose in lingerie at the casting. *What's the name of the casting director?* It's always nice to be able break the ice by saying, "Are you Ms. Smith? It's nice to meet you, and my agent Joe sends his greetings."

2 Dress appropriately. If they want you to show up with a suit on, make sure you do. Otherwise, wear neat, clean, form-fitting clothes. You should look stylish but you don't necessarily have to be wearing expensive clothes. Common attire might be as casual as jeans and a form-fitting top. Some agents will coach you on your outfit. Don't hesitate to ask your agent if you're unsure— that's part of their role as "coach."

3 Be punctual. There is no mistake that is more easily avoided than being late. Not only is it rude, but it leaves a big question about the model's professionalism. Who wants to hire a model who might also be late to the shoot, where many other people (also being paid high hourly wages) will be forced to wait? Leave a lot of extra time to get to the castings. Excuses of late trains or traffic jams don't cut it. If you're early, you can always go to a coffee shop and read a book or get a head start on your homework.

4 Arrive clean-faced or with very light makeup. They won't want to see you in heavy makeup, because they want to see you in "raw" form. Your hair should be clean but not overly styled. Your nails should be manicured and immaculate.

5 Attitude is everything. The goal is to walk in, dazzle the client, and give them the impression that you're totally professional and will be a lot of fun to work with. Obviously this means you're polite and genuinely friendly, but don't overdo it and try to ingratiate yourself with insincere compliments.

"It's understood that everyone is in this as a business," says casting director Michael Lange. "Don't be transparent. Just be pleasant and good-spirited."

right
A single "commercial" shot like this (which was used by an Internet provider) can pay as much as a major fashion campaign.

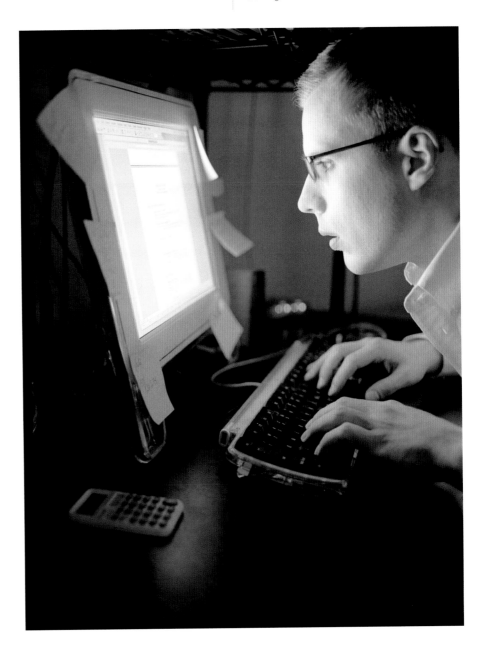

"casting calls are the business equivalent of a 1st or 2nd interview. they've seen your comp card (your 'resume') and now they want to meet *you*."

When you start out in modeling, you may have nothing more than a simple Polaroid picture taken in your agent's office (above). Likewise, this is all you need to get an agent in the first place! (See pages 94-103 for more information on getting an agent.)

Most castings are very informal. Sometimes it is a one-on-one event. At other times you will be meeting several people. There are even massive "cattle calls" with hundreds of models arriving and waiting their turn.

Once you have the casting director's attention, you'll usually show them your book or at least a Polaroid (see above). They may ask you to pose for a Polaroid or digital shot for reference. If you have a comp card, you would leave them a copy for reference.

bottom images:
Michael Lange of Micon Worldwide meets with models Amie Hubertz (bottom left) and Lindsey Kraft (below) and reviews their books during a casting call.

above:
New York City has the bulk of the nation's modeling work. If you want the biggest and best jobs, you'll need to move nearby so you can easily get to casting calls on short notice.

"if you walk in the door and you are exactly what the client had in their head — then they'll hire you. it's as simple as that." sam, ford models

Above:
Lindsey Kraft and Amie Hubertz arrive to a casting. Casual but fashionable attire is perfectly acceptable for a casting call, unless the client specifies otherwise.

Left:
Your agent will help you produce "comp cards," which are advertising promotions that you send or leave with potential clients. In the center is Lindsey Kraft's card. It is flanked by the front and back of Amie Hubertz's card. Both models are with Code Management.

runway casting

A runway casting director will usually start their selection process by calling modeling agencies and have them send in comp cards for their runway models. "I usually get about 1500 to 2000 cards, from which I do an initial edit based on my knowledge of the client," explains Michael Lange of Micon Worldwide.

"Obviously the models used for Ralph Lauren are going to have a different look than those used by Calvin Klein," he adds. Both companies have a different vision. It's my job to understand that vision and interpret it in the flesh."

Another consideration is to identify who is "burning up" the runways in Milan and walking Prada, Gucci, and Versace. These models would be considered "hot" because the fashion press is identifying them.

After Michael has pared down the field to 75 or 100, he will bring those cards to the client. These are further edited, and then about 40 or 50 are called in for a casting, before the final 20 or 25 are selected.

It is difficult to cast for women's runway models because the best ones are so much in demand. Most of the major shows are at set times of the year, so there is a lot of competition, and the agents for the models are worried about getting their models in the best shows.

"If you're dealing with top runway models, then chances are they have three or more second options on their chart," says Michael. "And almost everybody gets a second option on everything up until the 11th hour, and you don't get first options on the girls until a few days or maybe the day before."

Occasionally agents will try and make package deals, in which a designer must take several less-known models in addition to the top name. This allows their less experienced women to get more runway time at major shows.

This latter point includes knowing when to talk and when to be quiet. You'll need to become an expert on people, judging if they're in the mood for chit-chat or humor, or if they just want to keep everything moving along fast and methodically.

6 Confidence is another factor that is important. Self-confidence is infectious, as is a lack of confidence. Statistically you might go to dozens of castings before you're finally chosen for a single job. In the face of probable rejection, you still have to walk in with complete and total confidence that you're the best person for the job.

For runway work, confidence is especially important. "If a model isn't nervous with me now in the casting, then I know she'll do well on the runway with everyone else watching," says Mauricio Padilha, Mao Public Relations.

7 Remember that the people working the casting are probably very harried and under a lot of pressure to find the perfect model for the current job. Have your book and several copies of your comp card ready. *Don't* expect that you're going to have a long bonding session with the casting director, because it's not going to happen very often.

What David Grilli said about scouts at conventions definitely holds water here too: "Don't be insulted if I only give you 10 seconds because I have 200 other people to see— just make sure it's your best 10 seconds *ever*!"

We heard it confirmed over and over, that models without the greatest book still get cast again and again, because they "book themselves." In person, at the casting, they come off with a great combination of looks, personality, and professionalism. And they win the jobs that way.

coping with rejection

"there are plenty of women who are *extremely* good looking, the right height, the right size, and still they won't get a job. it can still be the luck of the draw."

amie hubertz, model

Confidence in the face of repeated rejection is an important skill for the model to master. Every client has personal taste and a goal for a particular job. It may or may not match your particular look.

"Even if you're Cindy Crawford, nine times out of ten you're not going to be 'right' for a given job," explains David Grilli. "There is a lot more rejection than acceptance in this business."

"When a client has a casting, they have a particular vision in their head of what the 'right' model for the job will look like," explains Sam. "When you walk in and you match it, they'll think 'this person is perfect' and you'll walk out with the job."

That's great if you are that *right* person, but more often than not, you walk out of the casting without the job. It does not mean that you were any more or less "beautiful" than the model who landed the job (or the other 298 at the casting who missed out). More likely it just means the winner matched the artistic criteria of the individual job better.

Perhaps one of the hardest things for any model to do is to keep their spirits up amongst all this "rejection." You may have been the wrong person for the last audition and feel awful. But the same client could end up hiring you for the next job. And you need to walk in just as confidently to that casting, because *confidence sells*.

To keep up your confidence, you have to believe you're good enough to be in the runway show or be chosen for the photo shoot. Most importantly, you have to understand that statistically you're more likely *not* to get the job, and the world will go on!

"Once I realized and really understood how unpredictable and subjective the industry was, I started to enjoy modeling more," reveals Amie Hubertz. "I took the rejections less personally."

On any given day, there are thousands of models who fit *all* the requirements of a particular job— they are extremely good looking, they have the right height, the right size, and even the right hair color and style. But they still won't get the job. It can still come down to just plain luck and timing, or a subjective consideration that only the client understands. And when your career swings on factors like these, it can be a very disconcerting feeling.

your first job

You may be tempted on your first job to come in "looking your best" in full makeup and perfect hair. Don't! It wastes everybody's time unless that was the specific request (such as a test shoot where there will be no makeup artist). When you arrive to a photo shoot, you should arrive on time with a clean face (no makeup), and no hair gel or spray. However, always tuck some of your own makeup in your purse in case the makeup artist has trouble matching your foundation.

"Know your hair," warns model Jodi Kelly. "I wash it the night before the shoot, because it lets a little oil come into the hair, which makes it easier for the hair stylist."

Wear non-binding socks, bras, and underwear to avoid lines. Should the shoot require a bared shoulder, you don't want everyone to have to wait an hour while the red mark from your bra strap disappears.

Most models bring along neutral underwear that matches their skin tone, including a thong or g-string. Women should bring several different bras from full coverage to low-cut, as well as bras that give their breasts different shapes. Include a white and black bra as well. Push-up inserts are also a good idea. However, none of these items need be fancy or expensive.

It's not uncommon for a client or photographer to ask you to wear no undergarments under a dress. This isn't a sexually motivated request— it simply avoids the potential problem of "panty lines" showing through the material.

makeup

Makeup artist Cyrus is insistent that models (both female and male) bring their own skin care products. This isn't because he's stingy! It's to avoid the possibility that the model has a bad reaction to the products. A red face or rash, won't just ruin the day's shoot, it could put the model out of work until it is completely healed.

One of the worst aspects of modeling is that after the makeup is applied, you can't touch your face for fear of wrecking the one or two hours of work that the artist has put into the makeup. And as everybody knows, as soon as you start thinking about the fact that you can't touch your face, it seems to suddenly become itchy!

Eating and drinking should be avoided after the makeup has been applied. But if it is a long day, there are ways to do it without affecting the work. Many models carry straws in their purse so they can sip at drinks without ruining the line of their lipstick. Most of us have been trained since childhood to delicately use our lips to cover our teeth when eating, but models must master the art of eating with their lips curled back so the food never touches the lipstick.

You'll also have to watch yourself for nervous, subconscious habits that almost everybody manifests in some way or another. For models, this manifestation *can't* be to twirl the hair or bite their lips. Like the makeup, the hair is not to be touched once the hair person has done their work.

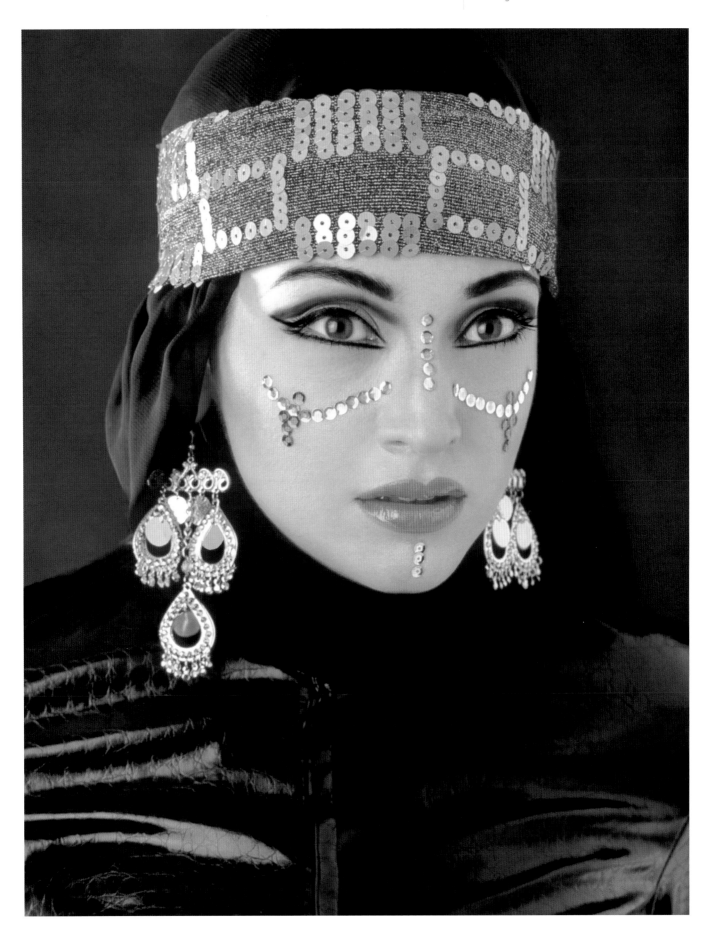

nine makeup tips

Makeup artist Cyrus offers several tips to models:

1. Come in rested. If you're tired or sick, you skin won't look or feel right. It will show even through the best makeup.

2. When you take off the makeup, especially heavy makeup, use a cold cream. During the height of the runway season (Fashion Week) the runway models must be very careful because they may be changing their makeup five times a day.

3. Both female and male models should bring their own skin care, so there is no risk of breaking out or having an allergic reaction. The model knows their skin best and how it responds to certain products. Everybody has different skin. Even if it says "hypoallergenic" it doesn't mean it has been tested against your skin.

4. Keep your skin clean and makeup free when you're not working. This will help keep it healthier for photography.

5. Wear sunblock any time you're outside, even if it's just to run to the store. By all means, don't sunbathe or visit the tanning salon unless your agent advises it for a certain look.

6. Don't pluck your own eyebrows. It's hard to do it yourself and get it even. Let a professional do it. Never wax the eyebrows, but instead use tweezers for more control.

7. Stop talking when it's time to do the intricate makeup, like lashes and lips! A perfectly still face is needed for this precision work.

8. Don't be surprised if you're in the makeup session for 90 minutes or more. This is common for a fashion shoot. Runway makeup is much faster (15 or 20 minutes) because of the number of models that need t o be prepared in a very short time frame.

9. Trust the creativity of the makeup artist and photographer. If you hate the look they've given you, be professional. Do the shoot and cash the check— no one says you have to use the photograph in your portfolio.

"keep your skin clean and makeup free when you're not working. this will help keep it healthier for photography."

cyrus, makeup artist

Makeup varies greatly with the creative intent of the photograph. Makeup for magazine editorials tends to be much more exotic or extreme. Fashion photography is all about beauty and fantasy. Beauty photography is cleaner and more detailed, so the makeup should be immaculate.

"In commercial work you have to make the people look like they do in daily life," says makeup artist Cyrus. For theater you have to extenuate and exaggerate everything—triple as dramatic."

"One of the most exciting parts of my job is to accentuate or alter people's features," adds Cyrus. "I can create so many different looks with just one model."

"If you see the makeup artist putting on extreme makeup for a fashion shoot, and it's not necessarily your thing, don't run into the bathroom and change it!" admonishes model Carmen Dell'Orisice. "Whether it is good or not, you have to trust the photographer and the creative team. A lot of people have put together this look. It's not your opinion that matters in the end."

Cyrus agrees wholeheartedly: "Before I even start the makeup, I know the concept for the shoot. Way in advance, the photographer and the art director have discussed what the look will be, and we're all on the same page. The model can't come in at the last minute and change all that, because she or he thinks they look 'better' another way. That's not what they're paid for."

Instead, it's good advice to talk with the photographer and the makeup artist and try to find out what is their intent. Are they trying to make you look sophisticated and refined, or dramatic and brash? The end result will determine how you should act and pose on set.

"As a model, I want to understand what the photographer is seeing," explains Carmen. "I watch the kinetic movement of the photographer. I want to understand what's in his head. I want to understand the nuances, so I can give him more. That's how special pictures happen."

"I also try to see the angle that the lens is at, and push everything to that point," adds Carmen. "I usually get so involved that I forget it's just pins that are holding the dress together," she jokes.

Every photographer has a different style for bringing the most out of their models.

Raphael Mazzucco likes to start his photography session with the tight shots, so he's up-close to the model and in their face. He feels that this creates an intimacy or closeness with the model. The link then lasts the rest of the day when he steps back for the more distant shots.

Other photographers are the exact opposite, doing the more distant shots first, believing that they are giving the model more time to warm up for the closer, "in-your-face" shots. Many use music to set the mood for the photographs. Some talk incessantly, while others seem mute. You'll need to work with everyone!

The makeup artist is an integral part of the creative team. A good artist can transform how you look, allowing you to create great variety in your portfolio. Variety will give you the opportunity to "match" the clients' needs more often, landing you more jobs.

Some models are "chamelions." Makeup, lighting, camera angles, or a combination of all three can make one person look totally different from photograph to photograph.

Master makeup artist Cyrus did the makeup for most of the photographs in this book, including the seven images of model Nicole that line the bottom of the page.

"Sometimes I use very bold colors to create a fantasy," says Cyrus. "I've also studied the history of makeup and hair, and love to bring historical references into my art."

"one of my favorite things to do is to transform the model. I can change the shape of their eyebrows, eyes, and lips for an entirely new look."

cyrus, makeup artist

posing

"it's very hard to look carefree, happy, and fun in a photograph while keeping you head at an exact angle so the jewelry looks perfect."

jodi kelly, model

new models sometimes find their early photo sessions are intimidating. The environment of the professional photo studio is unfamiliar and they are surrounded by strangers who all seem to know exactly what they are doing.

If you look at some of the "step-back" photos on pages 150 and 163, you may be surprised to see that the actual studio set-up looks vastly different from the final photo. The model finds herself in the middle of a foreign world surrounded by lights, tripods, reflectors, backdrops, and strangers. Yet she has to look as if she's somewhere else entirely.

As a model, you must learn that the way you pose changes with the type of modeling. Look at the poses in a top fashion magazine and compare them to a mainstream catalog. They're *very* different.

Catalogs are usually done very quickly. You might have to switch between 20 or 30 outfits in a day. The poses are much more conservative, and often the photographer expects you to have a repertoire of poses to call upon.

In a catalog shoot, generally you're on a white backdrop, and you are not the main focus of the picture. The focus is the outfit.

"You look good in the clothes? Good! Now smile," mimics Jodi when referring to a catalog shoot.

These shoots also go quickly— about ten minutes per outfit. You strike a pose that is appropriate, the photographer shoots about two rolls of film with slight variations, and then you change into the next outfit. The type or style of the poses usually stay fairly consistent, because they are going to be used in the same catalog.

For fashion, you tend to get much more individualistic and creative poses. The photographer is often more involved in creating the poses. You as a model are much more important to the overall picture. Certainly it is important to show the clothes, but the fashion shoot is more about creating an overall *feeling* in the photograph. In a catalog, the color, texture, and fit of the clothes are most important.

above
When deciding how to pose, the model should consider the clothing, the makeup, the design of the set, the lighting, and the stated creative intent of the picture. Sometimes the photographer will pose you or coach you, but often they will want you to "try something spontaneous."

The types of poses also differ based on the lighting, backdrop, makeup, and clothing itself. It will often be up to you to bring it all together, so be aware of how these things all interact.

practicing poses

Learning to pose well is time consuming. Determining when to use certain poses takes practice. When inexperienced models "strike a pose" that they've seen in a magazine, it can be laughable if it is in an inappropriate setting.

"A new kid just testing the waters is going to be nervous and not know what to expect on a photo shoot," explains Michael Lange, Micon Worldwide.

Not only does she or he lack confidence, but they also have fewer set poses to draw inspiration from, so sometimes they stand there and freeze. When in doubt, ask the photographer. It's always okay to suggest, "How about this or that?"

It is important that the model take an inventory of his or her body before the photographer starts shooting. Where are my

below
Posing for jewelery shots is difficult because the model usually poses so that the jewelry is kept at a precise angle in relationship to the lights.

hands? Where are my feet? Where are my hips? And how are they positioned in relationship to the photographer?

At all times on set, you should be aware of the distribution of your weight. An understanding of your own body and the way it balances is the key to posing well. Some people know this instinctively. Others must learn and perfect it through disciplines such as Yoga, Tai Chi, and Pilate's.

Dancers commonly practice in front of a mirror to perfect their movements, and models should do the same. Even though your movements will be caught in a single image, graceful motion records more gracefully on film. Models can find inspiration not only in photographs they like, but also by observing graceful styles of dance, including ballet, modern, and even Flamenco and the dances of other cultures.

Though some photographers will coach a model into an exact pose, more often they start from a more general position and let the model "try something" and then work from there. The best photographs come from a collaboration, with both model and photographer each contributing ideas, so that one pose flows into the next, and each roll of film has a lot of variations.

Of course, there are times when no input from the model is wanted or needed, such as when the photographer has been given a very precise sketch or concept from the creative team and is expected to match it.

A good example of a technical photo shoot was one that Amie Hubertz did for Clinique: "It was a close-up of my eye with a makeup brush. I was standing with the camera two inches from my face, and I had my head supported from behind to keep me in the exact position. Someone else was holding the makeup brush in

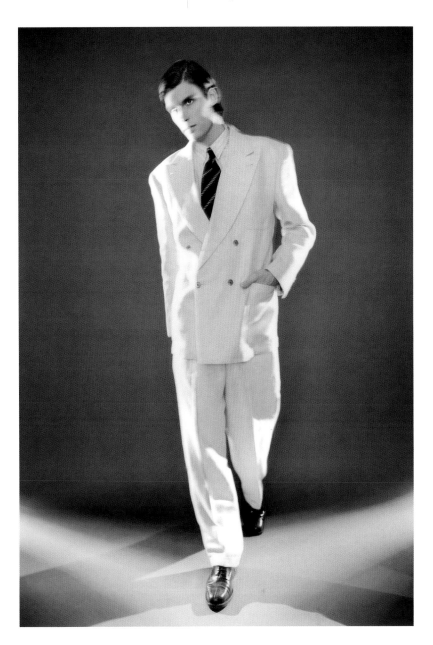

above
Posing includes movement, such as this walking shot. Ease of movement even on small sets is an important skill in posing.

place. It was basically a still-life photo using my face as a prop for the eye shadow and brush."

"It was a very difficult shot," she adds. "I just had to be very, very professional and do exactly what I was being paid to do— which in this case was to stay still, not scratch my itchy eye, and not blink too much!"

Photographing two people together can also be an odd feeling for a novice. Usually, two strangers would keep a certain personal distance away from each other. But in photography, too much space between the models would make the image look gappy, so they are moved much closer together. A tight head shot of two friends laughing together is a good example. The two models, who may have met for the first time that morning, now have to spend two hours laughing with their cheeks pressed against each other. It is uncomfortably close, but it needs to be done to make the *photograph* look real.

Jewelry is also a very technical shot, because of its shiny nature. It is important that the lighting hit the jewelry at a particular angle for it to look it's best. And since the lighting is stationary, it means the model has to keep the jewelry at the right angle.

"It's very hard to look carefree, happy, and fun in a photograph while keeping your head at an exact angle so the jewelry looks perfect," explains one model. "So while my movements have to be careful and precise for the camera, it can't look stiff in the final photos!"

Some models prefer the more technical work. "I'm a math and science person. That's how my mind works, so I relate well to that type of photography," admits one model. "When I have to do a catalog and jump around and smile a lot, I can't wait to go home and rest my poor aching cheeks that have been smiling all day."

Others, like Lindsey Kraft who considers her smile one of her best attributes, loves to play the happy teen role in magazine editorials as well as catalogs. And Todd Riegler happily did an editorial shoot for *GQ* that required 10 hours of full body paint before the photograph could be taken (pages 52-53). A model with less patience would have considered that one of their worst jobs.

There is definitely a correlation between what you like to do best, and what you get hired for most. If you're really enjoying yourself it will show in the photographs, and it will show in the client's willingness to hire you again and again.

below
Posing for commercial print is more "real" and natural than what you would find in fashion.

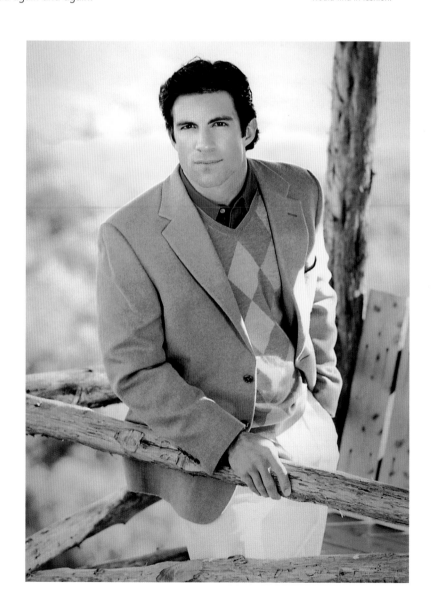

"some
photographers
don't know
how to tap
the well.
that's when
experience
as a model
can help
you." carmen, model

7

additional information

a glossary to help you learn the lingo and an index to pinpoint information

glossary

You'll hear these terms thrown around a lot in the modeling industry. Learn them if you want to seem "in-the-know"!

3/4 SHOT: A photograph that shows at least three-quarters of the body.

8x10 GLOSSY: Technically, this is a type of photographic print. But some people may use it to refer to your "*head shot.*"

ADVANCE: Money that is paid to the model by the agency, before the client has paid the agent.

ADVERTISING AGENCY: A company that is hired to produce advertisements for another company. Do not confuse an advertising agency with a *modeling agency.*

AFTRA: American Federation of Television and Radio Artists.

AGENCY: In this book, an agency refers to a *modeling agency.*

AGENT: A person who works in a modeling agency, or the agency itself.

ART DIRECTOR: The person in charge of the visual look of a magazine or advertisement. Often, the art director has much say in choosing the model who will be hired for the job.

AUDITION: Usually the acting version of a casting call.

BACKDROP: The background material in a studio, which is often cloth, a roll of seamless paper, or a painted wall.

BEAUTY: A type of modeling and photography, often associated with the cosmetic industry.

BOARDS: A modeling *division*, such as the Women's Division is also called a board. The term comes from the bulletin boards that used to (and still do) hang in the front office of most *modeling agencies*. The *comp cards* of the current models are on these boards.

BODY MODEL: A model that has an excellent physique, who specializes in nude, nearly nude, and fitness images.

BOOK OUT: Times or dates that a model doesn't want to work are "booked out."

BOOK: This is a model's portfolio, usually a large book or album that shows photographs and tearsheets of the model. It is an important tool for getting hired.

BOOKER: A term that usually refers to the person in charge of booking (hiring) a model for a client. Some people in the industry also refer to agents as bookers.

BOOKING: An actual confirmed job.

BUYER: Usually refers to the person who orders the clothing and other products that will be sold in stores and catalogs.

BUYERS' SHOW: A smaller version of a *runway show*, usually geared for fashion *buyers* rather than the press.

CALL BACK: If a model does well in a casting call, he or she may be "called back" so the client can have a second look.

CALL SHEET: A model's schedule or calendar, which is often kept by the agent.

CAMPAIGN: A group of advertisements that feature a common theme.

CASTING CALL: An audition, where the model meets the client or the *casting director* in person.

CASTING DIRECTOR: The person in charge of hiring models for a particular project.

CATALOG WORK: Modeling clothes and accessories for a catalog.

CATTLE CALL: A slang term for a casting call in which there are so many models attending, it seems like they are cattle being herded into the stockyard.

CLASSIC: A division that features older, more mature female models.

CLEAN-FACE: Without makeup.

CLIENT: Any one who hires a model. It can refer to a manufacturer, advertising or PR agency, or magazine, or a specific person at these businesses.

CLOSED SET: A photo shoot where the number of people present is minimal—such as just the photographer, the model, and an assistant. Nude photographs are often done on a closed set.

COMMERCIAL PRINT: A modeling specialty driven by products that are not related to *High Fashion*.

COMP CARD: A term for a model's advertising flyer, which usually has a composite of one or more pictures (usually at least a head shot and a body shot), as well as other pertinent information.

CONTRACT: Generally a contract refers to a legally binding document between the agency and the client concerning the parameters and fees for a certain job. A contract that describes a model's business relationship with his or her *modeling agency* is sometimes referred to as either a contract or an agreement.

CONVENTION: A business that brings aspiring models and actors together with modeling and acting agents. Often it is a large extravaganza with lectures, a runway show, and interviews with the agents.

CONVENTION MODEL: A model that works at conventions to meet and greet attendees. Often they must be knowledgeable about the products or services being offered by the company that hired them.

CREATIVE DIRECTOR: See *art director*.

DAY RATE: Models are sometimes hired by the hour, by the day, or by the job. A day rate is a fee paid by the client for a day of modeling.

DEMONSTRATION MODEL: see *convention model*.

DEVELOPED: A term often used by agents that refers to the efforts they make to teach a model the business, and "develop" an image for them.

EDITORIAL: An article or picture spread in a magazine.

EDGY: A model is considered "edgy" if they have a very trendy, cutting edge look.

FASHION MODEL: This usually refers to a model that poses for the fashion magazines and *haute couture* fashion designers.

FASHION WEEK: Set times of the year when clothing designers showcase their new lines. Also called *Market Week*.

FITTING: Prior to a fashion photo shot or a runway show, the model might need to attend a fitting session to see if the clothes must be altered for proper fit.

FREELANCE: A model who does not have an *agent*. This could be a person in-between agents, someone who models part-time, or a person who is modeling as a hobby or "for fun."

FULL-LENGTH: A photograph that shows the model's entire body.

GO-SEE: A slang term for a *casting call*.

GUARANTEED VOUCHER: When an agency agrees to take care of the billing and collection from a client.

HAIR STYLIST: The person who styles the model's hair for a photo shoot. Do not confuse this person with the stylist, who is responsible for the clothing and accessories.

HAUTE COUTURE: The specialty of high fashion (French term). This is what most people envision when they hear the words "fashion model."

HEADSHEET: A group of headshots, usually models from one agency.

HEADSHOT: A photograph of a model or actor that shows their head and shoulders. Usually it gives a good representation of what the person actually looks like.

HIGH FASHION: See *haute couture*.

IN-HOUSE: Refers to someone that works for a company.

JUNIOR CATALOG: A catalog that uses teenaged or child models because the products are geared to that age group.

LOCATION: See, *on location*.

MAJOR MARKETS: See *primary markets*.

MAKEUP ARTIST: The person hired to apply the makeup to the model before a photo shoot.

MARKETS: See *primary markets*.

MARKET WEEK: Set times of the year when clothing designers showcase their new lines. Also called *Fashion Week*.

MODEL BOOKER: See *booker*.

MODEL MANAGEMENT COMPANY: Another term for a *modeling agency*.

MODEL RELEASE: A document in which a model grants a photographer or client the rights to use photographs taken of them in a certain manner.

MODELING AGENCY: A company that helps models get modeling jobs, develope their image, and manage their careers, in exchange for a commission (a percentage of the model's income). Also called a model agency.

ON LOCATION: A photo shoot that is not done in the photographer's studio. It can be indoor or outdoor.

OPEN CALL: A *casting call* with few limits on who can attend. *Modeling agencies* often hold open calls so that aspiring models can come in and meet their *scouts*.

OPTION: This basically means a model is on hold for a job. First options get priority over second and third options.

PARTS MODEL: A model who specializes in hands, feet, hair, or other body parts.

PETIT MODEL: A model who is shorter than the 5'9" norm. There is no such thing as a Petit Division in the *major markets*, but some smaller markets do have opportunities for shorter models.

PHOTO SHOOT: A session in which a model is posing for a photographer. Often it refers to the shooting of an actual job.

POLAROID: A brand name that many industry insiders use to generically refer to a non-professional snapshot taken of a model.

PORTFOLIO: See *book*.

PRIMARY MARKETS: New York City, Chicago, and Los Angeles are the biggest ("primary") markets for models in the USA. Most of the best and highest paying modeling jobs are in these cities, with New York City being the largest of all the American markets.

QUASI-SCAM: A business or individual that is on the borderline between being a legitimate business and an illegal *scam*.

REEL: A movie or television version of a model's book or portfolio.

RUNWAY SHOW: An event that features models dressed in a designer's outfits walking down a runway. It is primarily a media event done to get publicity for the designer.

SAMPLE: An outfit, dress or article of clothing that is a pre-production "sample," which is often handmade by the designer.

SCAM: A business that is designed to con unsuspecting people out of their money. Well-run model-related scams can look very much like a legitimate business, but they prey on the hopes and dreams of aspiring models.

SCOUT: A person who works to "find" potential new models. Most scouts are paid by the *modeling agencies*.

SEAMLESS: A rolled paper backdrop used by photographers to create a white or colored background.

SECONDARY MARKETS: Cities that have a healthy modeling industry, but the industry is not as big as in the *primary markets*.

SPEC: Short for "speculation." If a model takes a job on spec, it means they only gets paid if the person who hired them gets paid.

SPREAD: Two facing pages in a magazine or book.

STROBE: A slang term for the large flash lighting units in a photo studio.

STYLIST: Generally the person in charge of wardrobe. Do not confuse with the *hair stylist*, who is usually a different person.

TALENT: A slang term for a model or actor.

TEARSHEET: A page torn out of a magazine or catalog that shows how the model has been used by other clients.

TEEN DIVISION OR BOARD: A division in larger agencies that features wholesome looking teenagers for the teen market.

TEST SHOT OR TESTING: A non-paying photography session in which both the photographer and the model wave their fees. It is a symbiotic way for photographers and models to create great images for their respective *portfolios* or *books*.

UNDER 5: A term used for actors in film or television who speak under five lines or a similar amount of exposure.

USAGE FEES: The rates an agent is able to negotiate with the client that are dependent upon how the image is used, such as "unlimited worldwide usage rates."

ZED (Z) CARD: An older, outdated term for a *comp card*.

index